A TREASURY OF
IRISH BLESSINGS

COURAGE
BOOKS

AN IMPRINT OF RUNNING PRESS
PHILADELPHIA · LONDON

9 8 7 6 5 4 3 2 1
Digit on the right indicates the number of this printing

Library of Congress Cataloguing-in-Publication Number 2002100369
ISBN 0-7624-1396-4

Cover and interior design by Dustin Summers
Edited by Michael Washburn
Photographs researched by Susan Oyama
Typography: Bembo, Kells

Published by Courage Books,
an imprint of
Running Press Book Publishers
125 South Twenty-second Street
Philadelphia, Pennsylvania 19103-4399

Visit us on the web!
www.runningpress.com

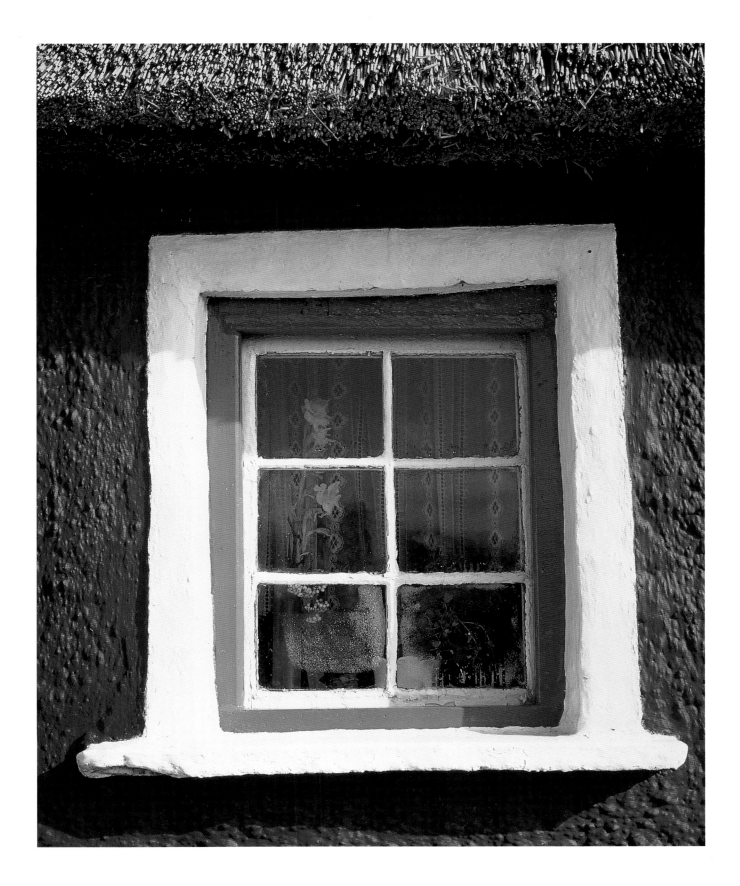

PRELUDE

STILL SOUTH I WENT AND WEST AND SOUTH AGAIN,

THROUGH WICKLOW FROM THE MORNING TILL THE NIGHT,

AND FAR FROM CITIES, AND THE SIGHTS OF MEN,

LIVED WITH THE SUNSHINE, AND THE MOON'S DELIGHT.

I KNEW THE STARS, THE FLOWERS, AND THE BIRDS,

THE GREY AND WINTRY SIDES OF MANY GLENS,

AND DID BUT HALF REMEMBER HUMAN WORDS,

IN CONVERSE WITH THE MOUNTAINS, MOONS, AND FENS.

— J.M. Synge (1871-1909)

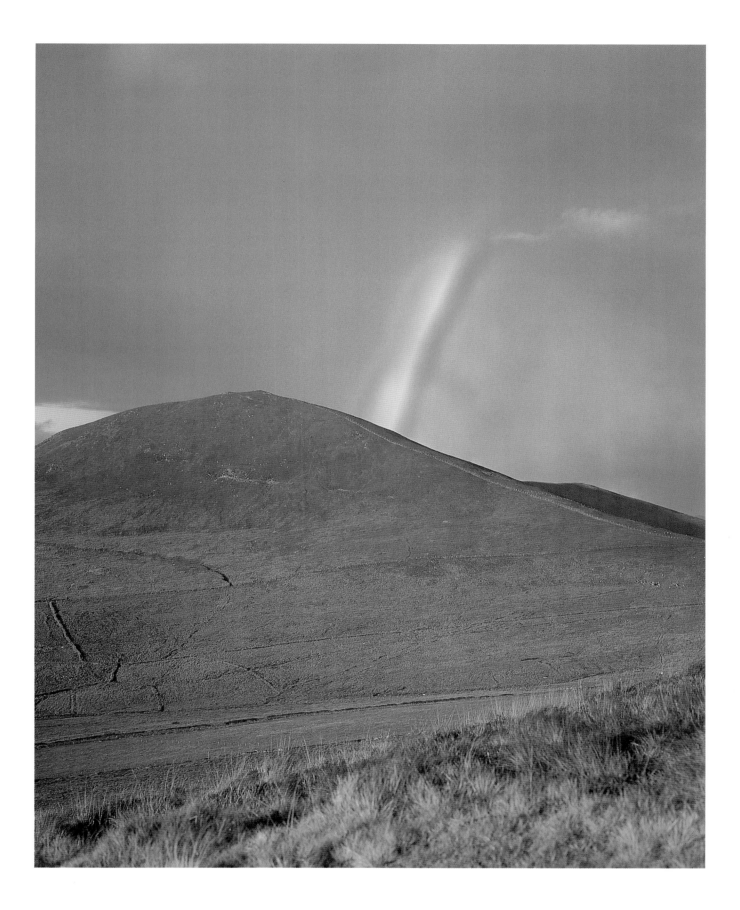

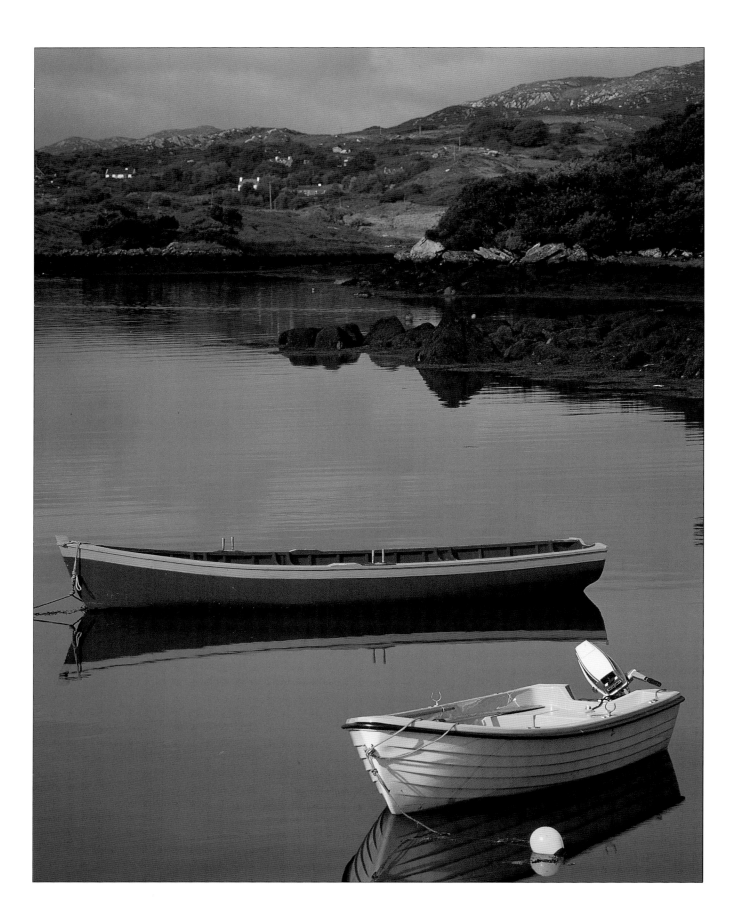

WHERE DIPS THE ROCKY HIGHLAND

OF SLEUTH WOOD IN THE LAKE,

THERE LIES A LEAFY ISLAND

WHERE FLAPPING HERONS WAKE

THE DROWSY WATER-RATS;

THERE WE'VE HID OUR FANCY VATS,

FULL OF BERRIES

AND OF REDDEST STOLEN CHERRIES.

— William Butler Yeats (1865-1939)

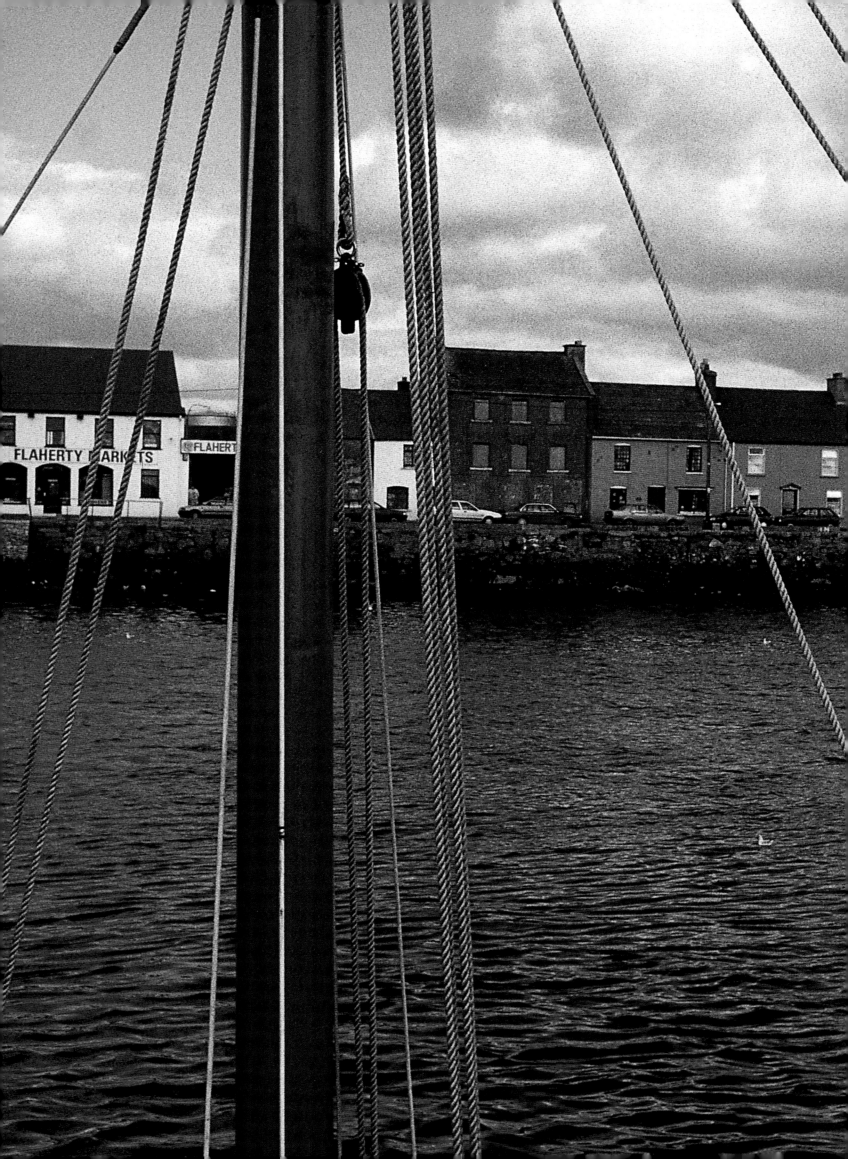

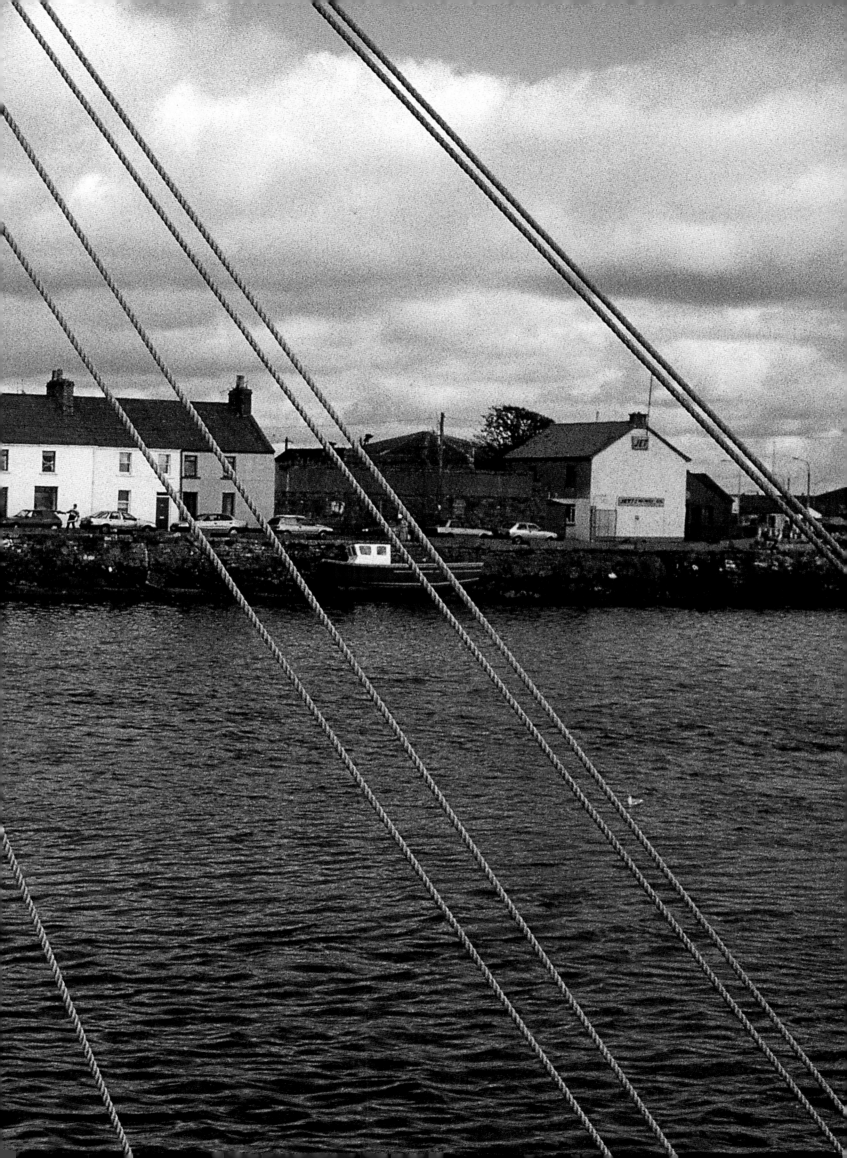

WHERE THE WANDERING WATER GUSHES

FROM THE HILLS ABOVE GLEN-CAR,

IN POOLS AMONG THE RUSHES

THAT SCARCE COULD BATHE A STAR,

WE SEEK FOR SLUMBERING TROUT

AND WHISPERING IN THEIR EARS

GIVE THEM UNQUIET DREAMS;

LEANING SOFTLY OUT

FROM FERNS THAT DROP THEIR TEARS

OVER THE YOUNG STREAMS.

— William Butler Yeats (1865–1939)

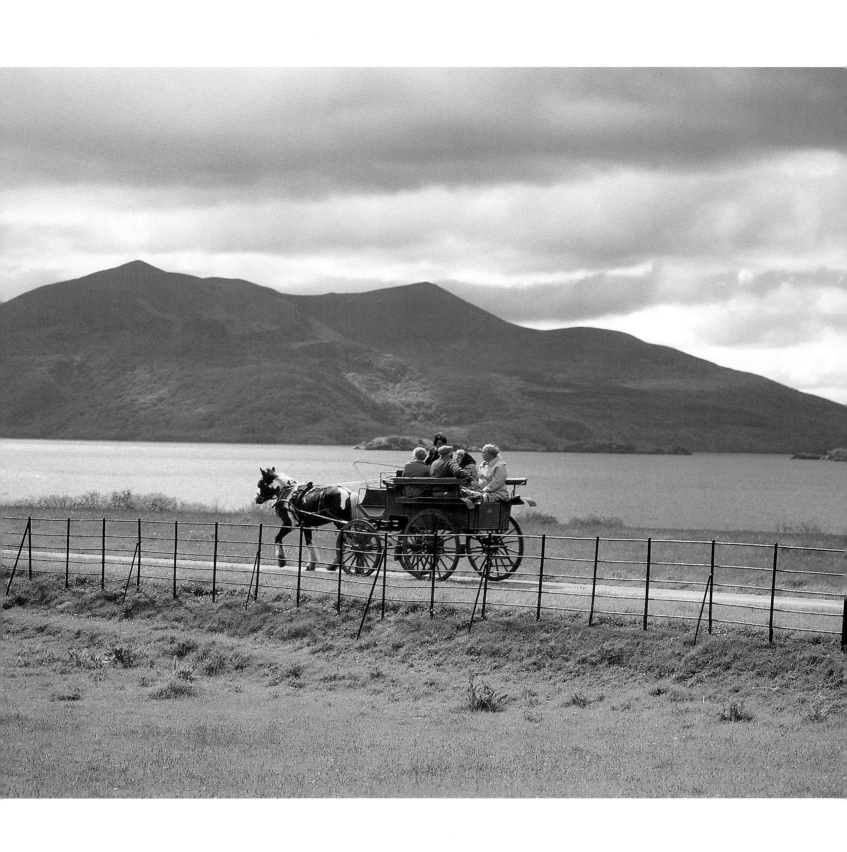

MAY YOU LIVE

ALL THE DAYS

OF YOUR LIFE.

— Jonathan Swift (1667-1745)

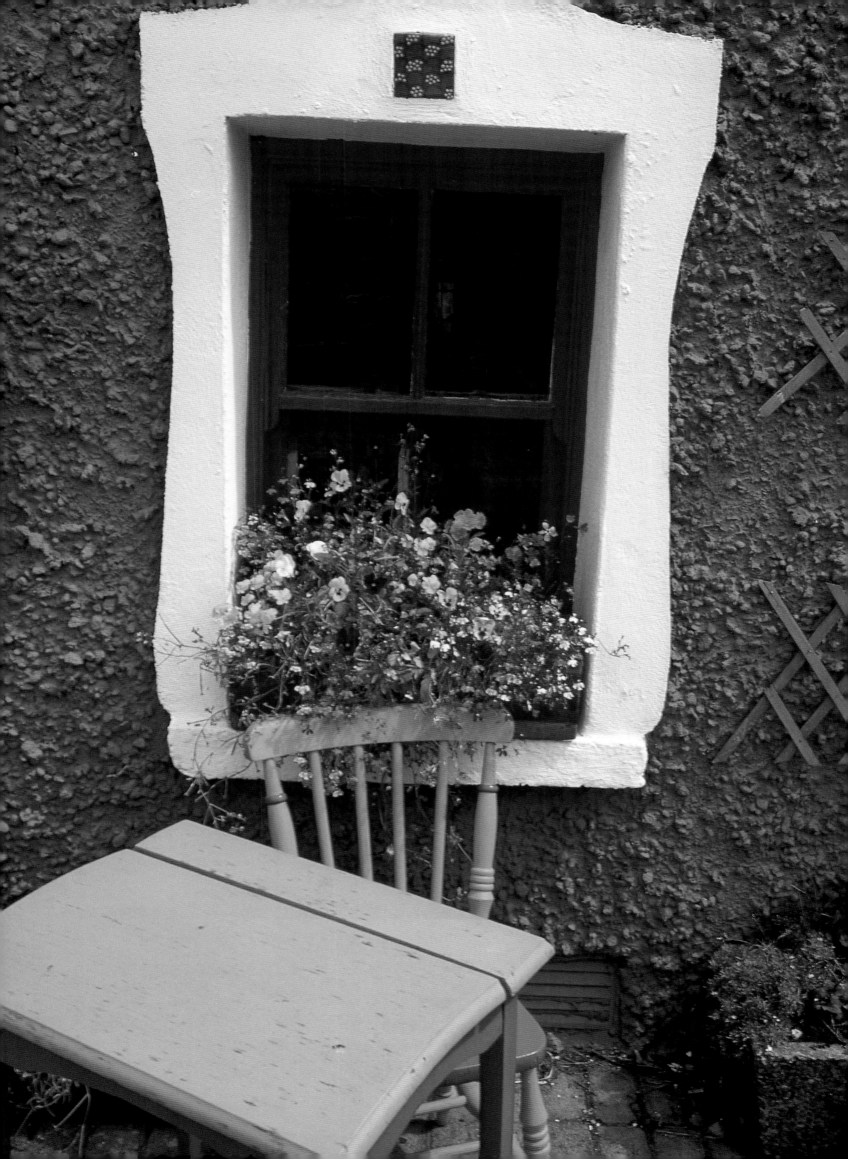

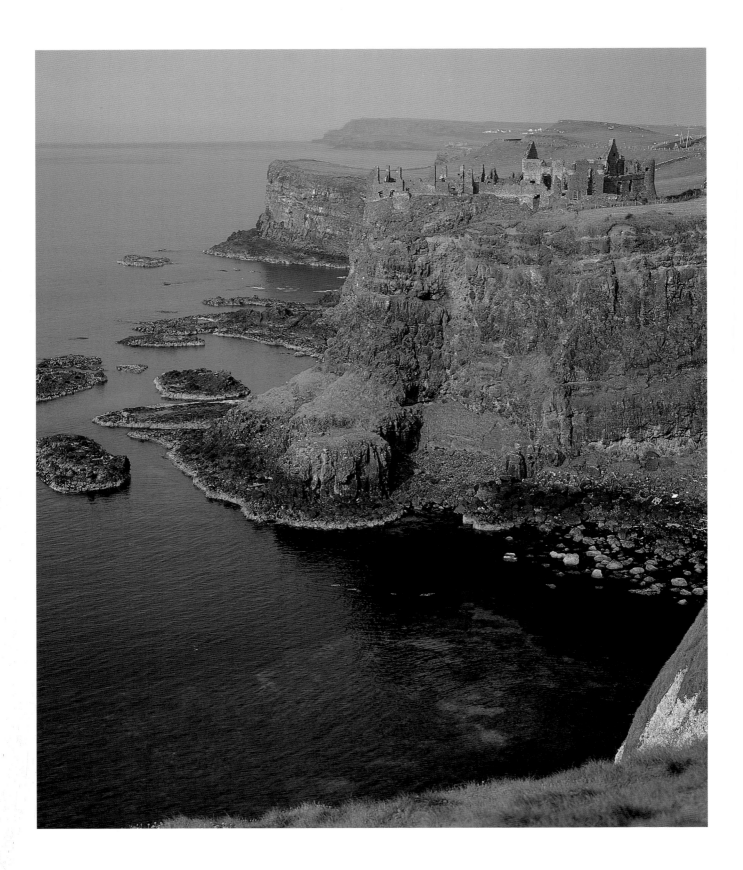

SHY ONE, SHY ONE,

SHY ONE OF MY HEART,

SHE MOVES IN THE FIRELIGHT

PENSIVELY APART.

SHE CARRIES IN THE DISHES,

AND LAYS THEM IN A ROW.

TO AN ISLE IN THE WATER

WITH HER WOULD I GO.

SHE CARRIES IN THE CANDLES,

AND LIGHTS THE CURTAINED ROOM,

SLY IN THE DOORWAY

AND SHY IN THE GLOOM;

AND SHY AS A RABBIT,

HELPFUL AND SHY.

TO AN ISLE IN THE WATER

WITH HER WOULD I FLY.

— William Butler Yeats (1865-1939)

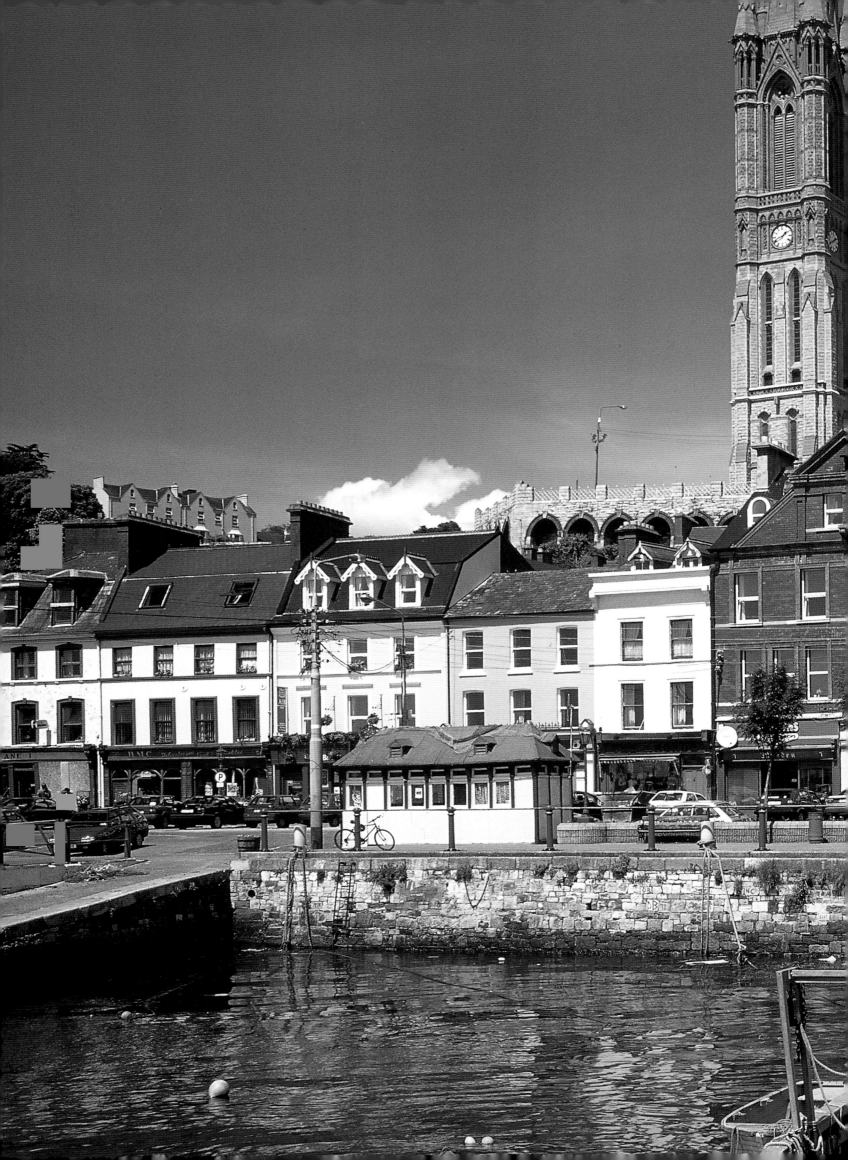

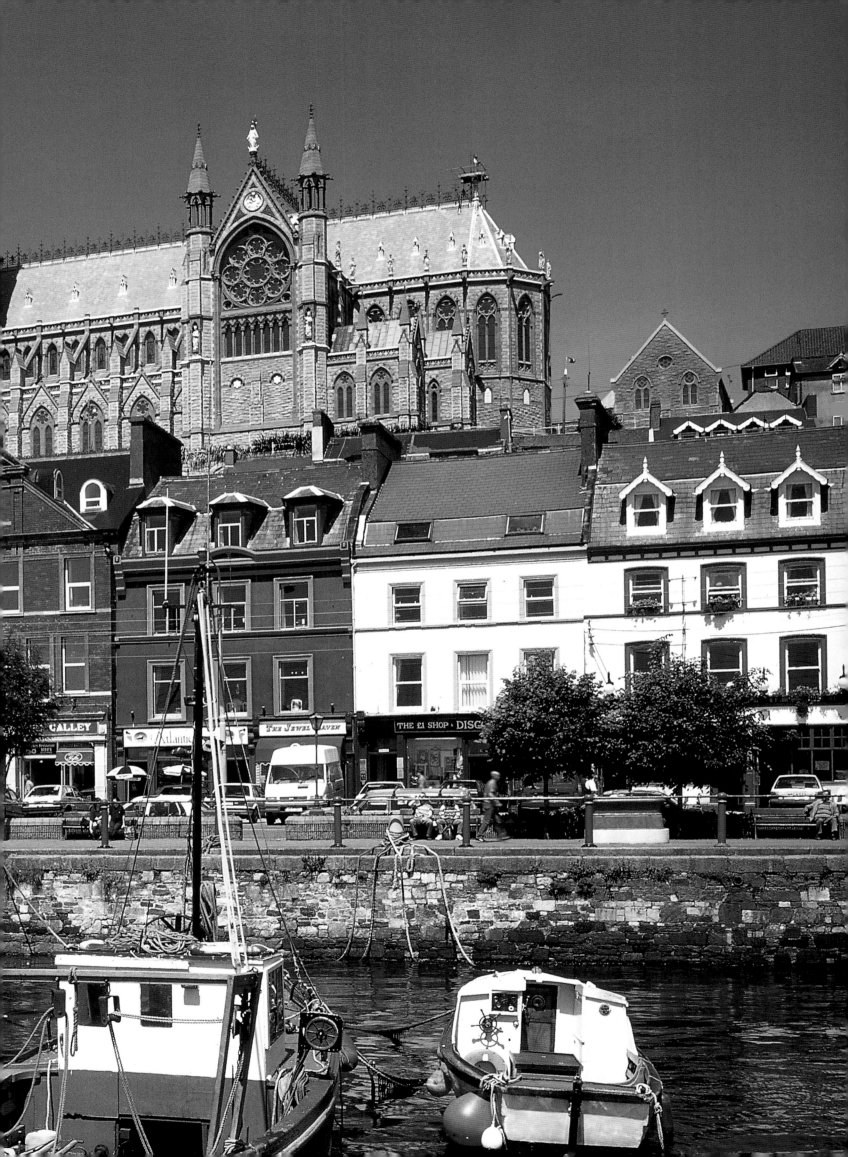

The trees are in their autumn beauty,

The woodland paths are dry,

Under the October twilight the water

Mirrors a still sky;

Upon the brimming water among the stones

Are nine-and-fifty swans.

— William Butler Yeats (1865–1939)

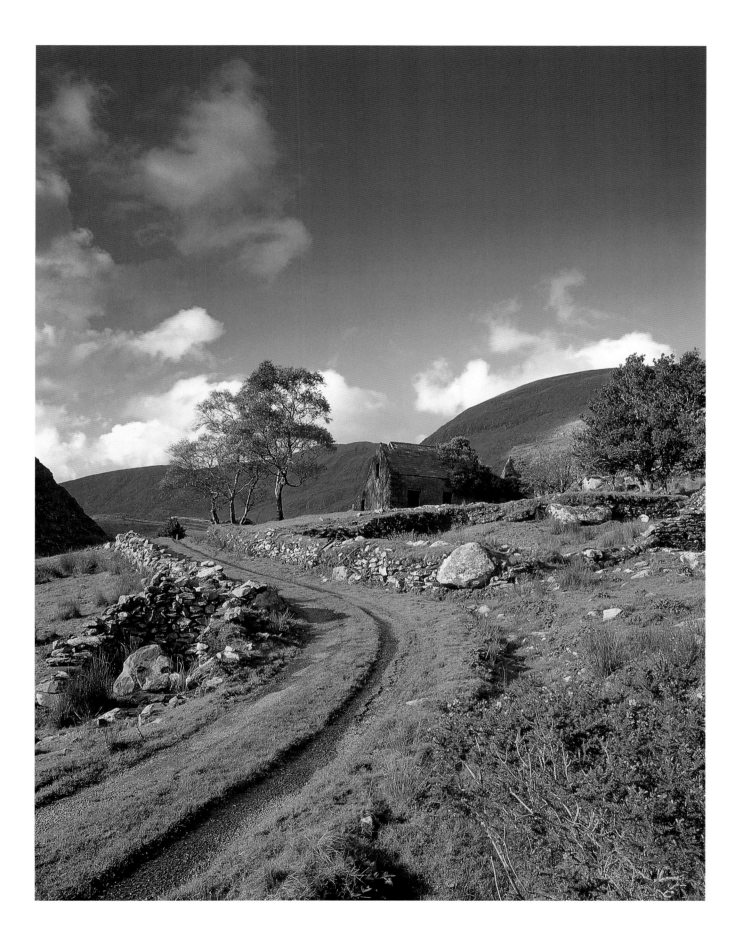

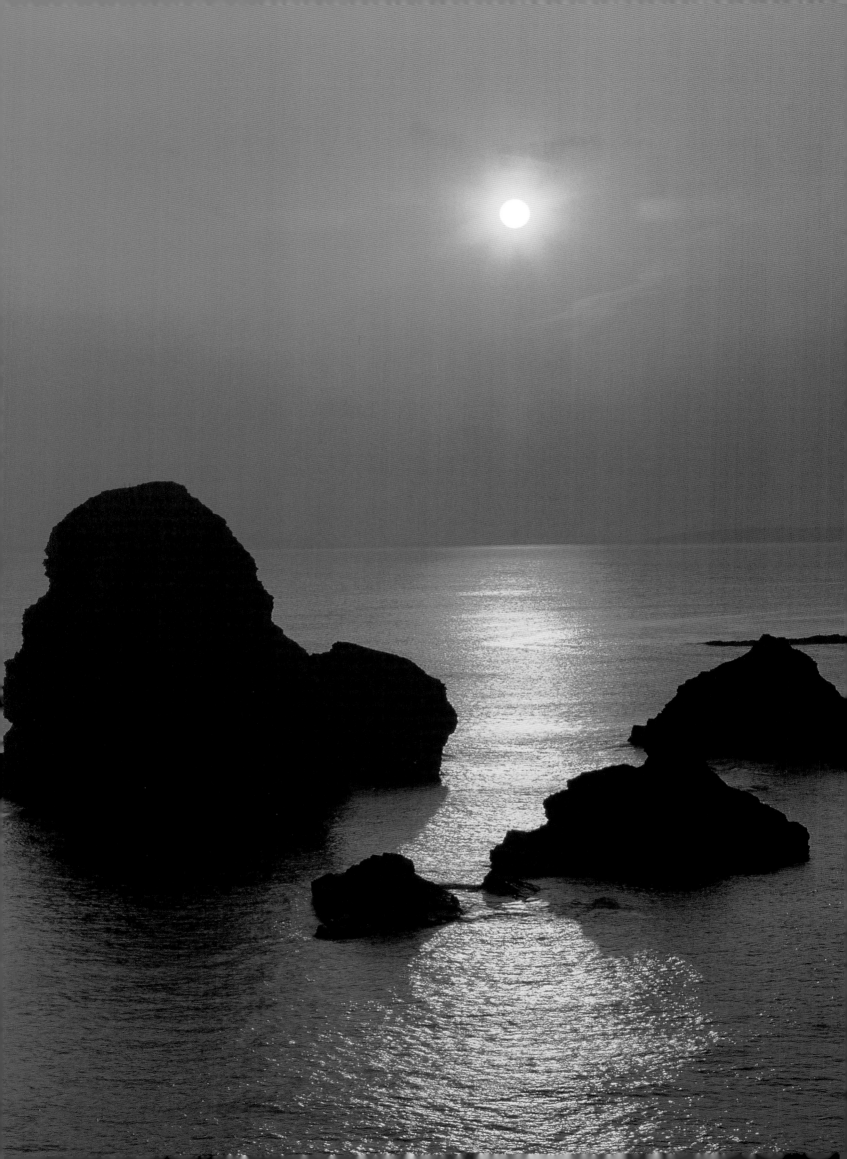

THE PURITY

OF THE UNCLOUDED MOON

HAS FLUNG ITS ARROWY

SHAFT UPON THE FLOOR.

— Jonathan Swift (1667–1745)

DOWN BY THE SALLEY GARDENS

MY LOVE AND I DID MEET

SHE PASSED THE SALLEY GARDENS

WITH LITTLE SNOW-WHITE FEET.

— William Butler Yeats (1865–1939)

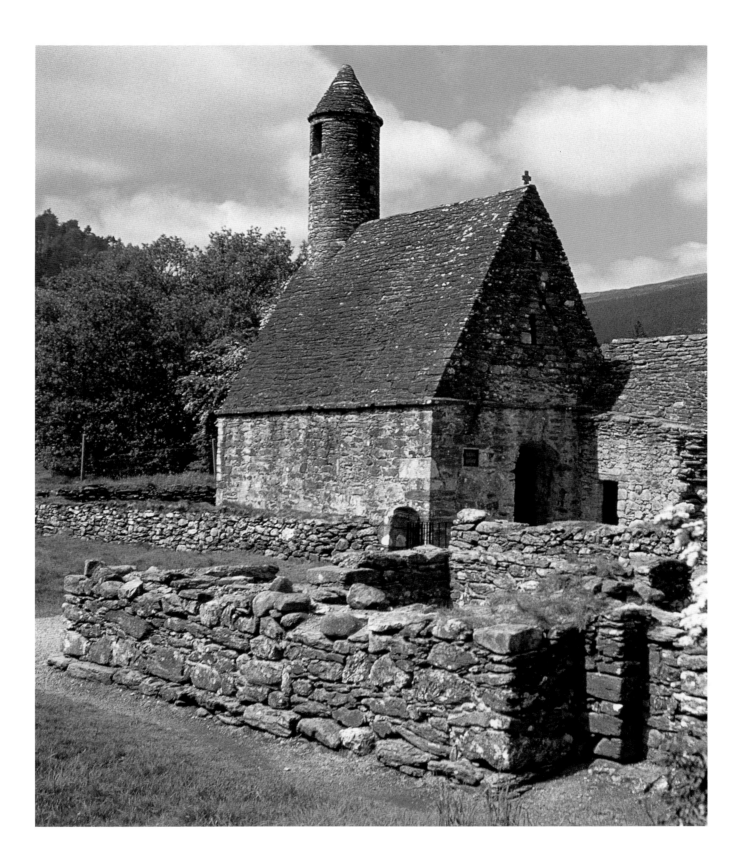

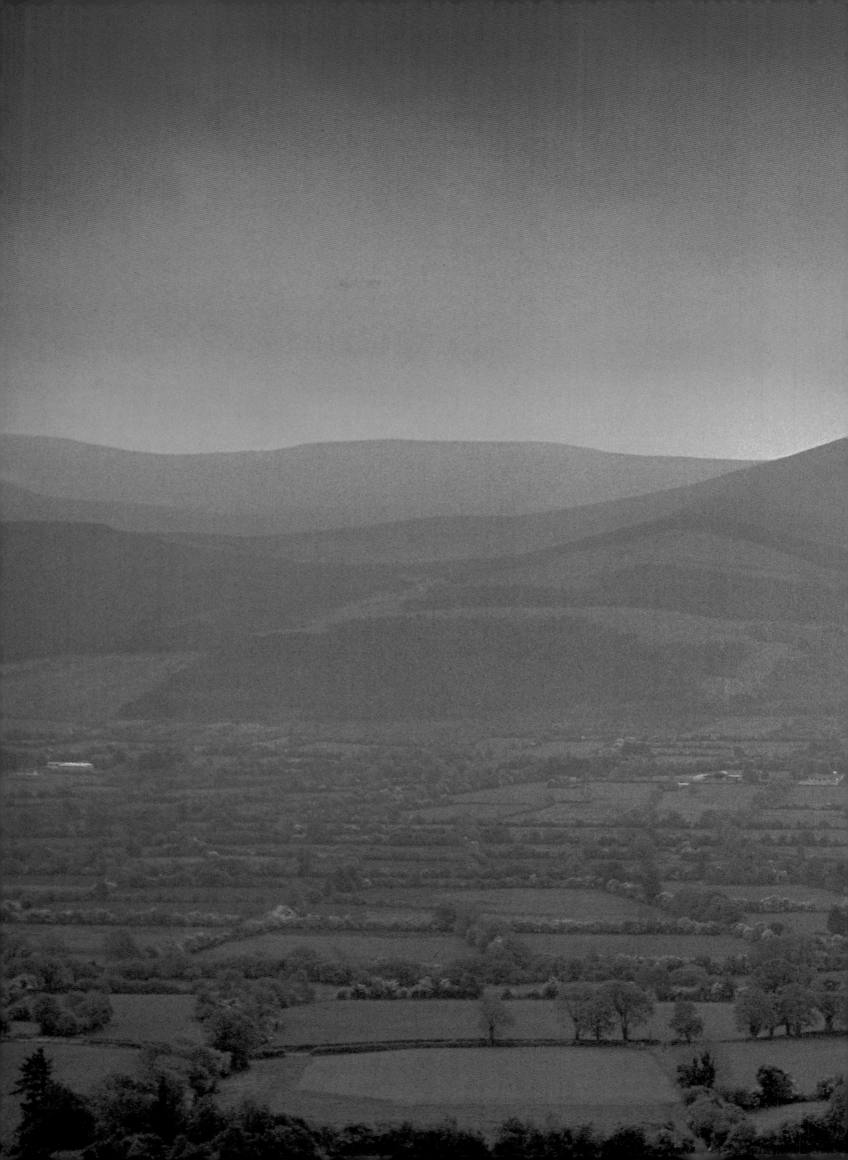

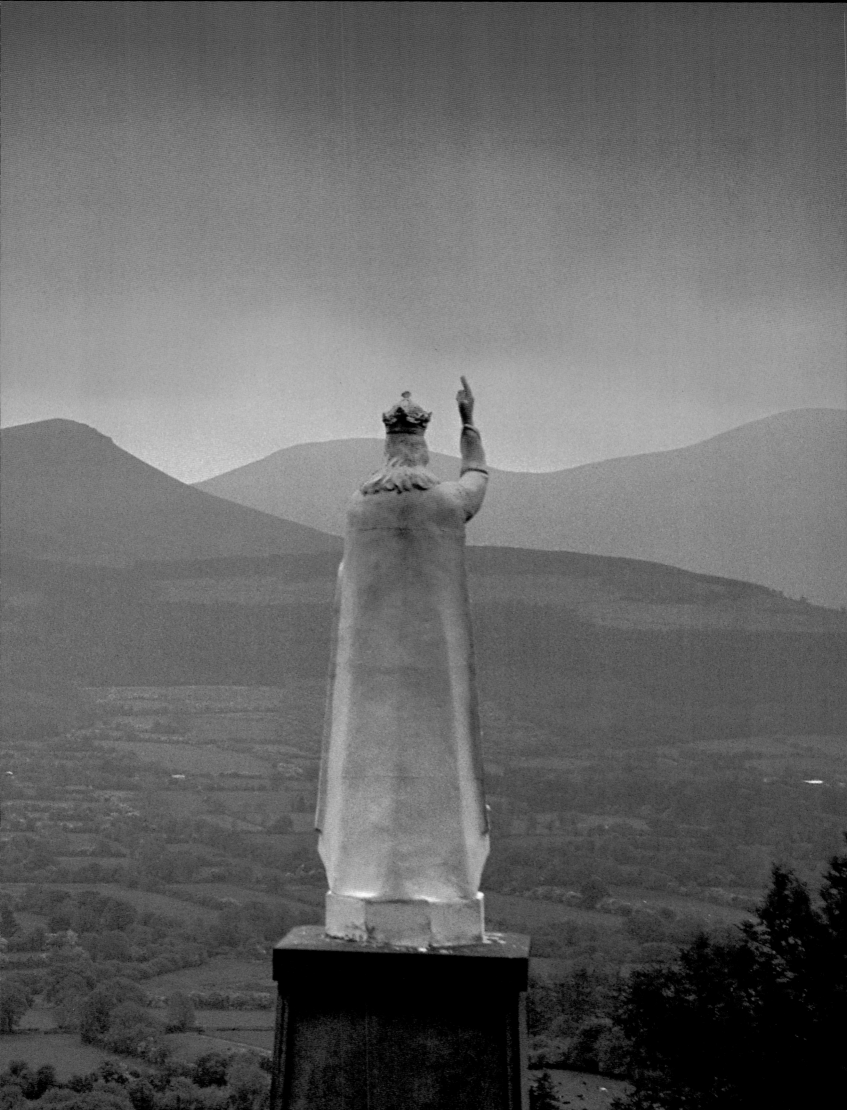

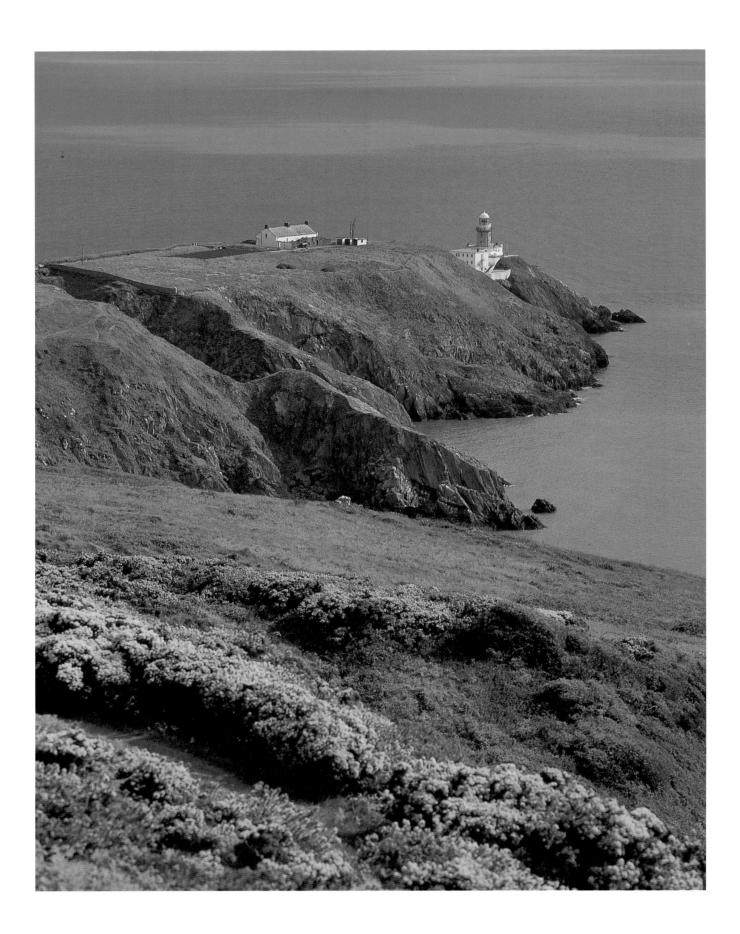

May the Irish hills caress you.

May her lakes and rivers bless you.

May the luck of the Irish enfold you.

May the blessings of Saint Patrick behold you.

Now sweetly lies old Ireland,

Emerald green beyond the foam,

Awakening sweet memories,

Calling the heart back home.

May Ireland's voice be ever heard,

Amid the world's applause!

And never be her flag-staff stirred

But in an honest cause!

— Thomas Davis
Irish Poet (1814–1845)

There's a dear little plant that grows in our isle

'Twas Saint Patrick himself sure that set it

And the sun on his labor with pleasure did smile

And a tear from his eyes oft-times wet it

It grows through the bog, through the brake,

through the mireland

And they call it the dear little Shamrock of Ireland.

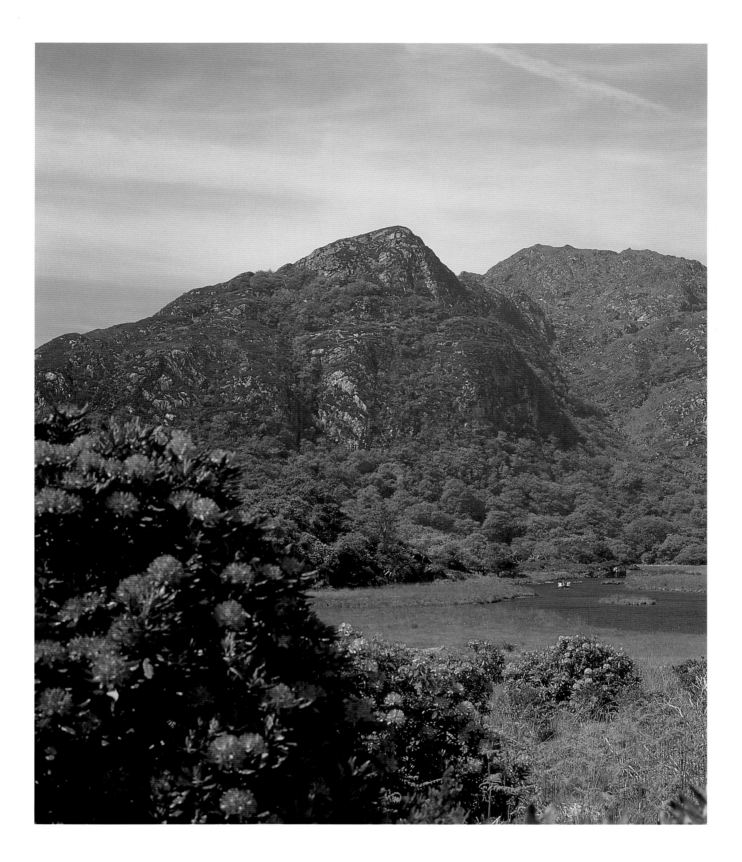

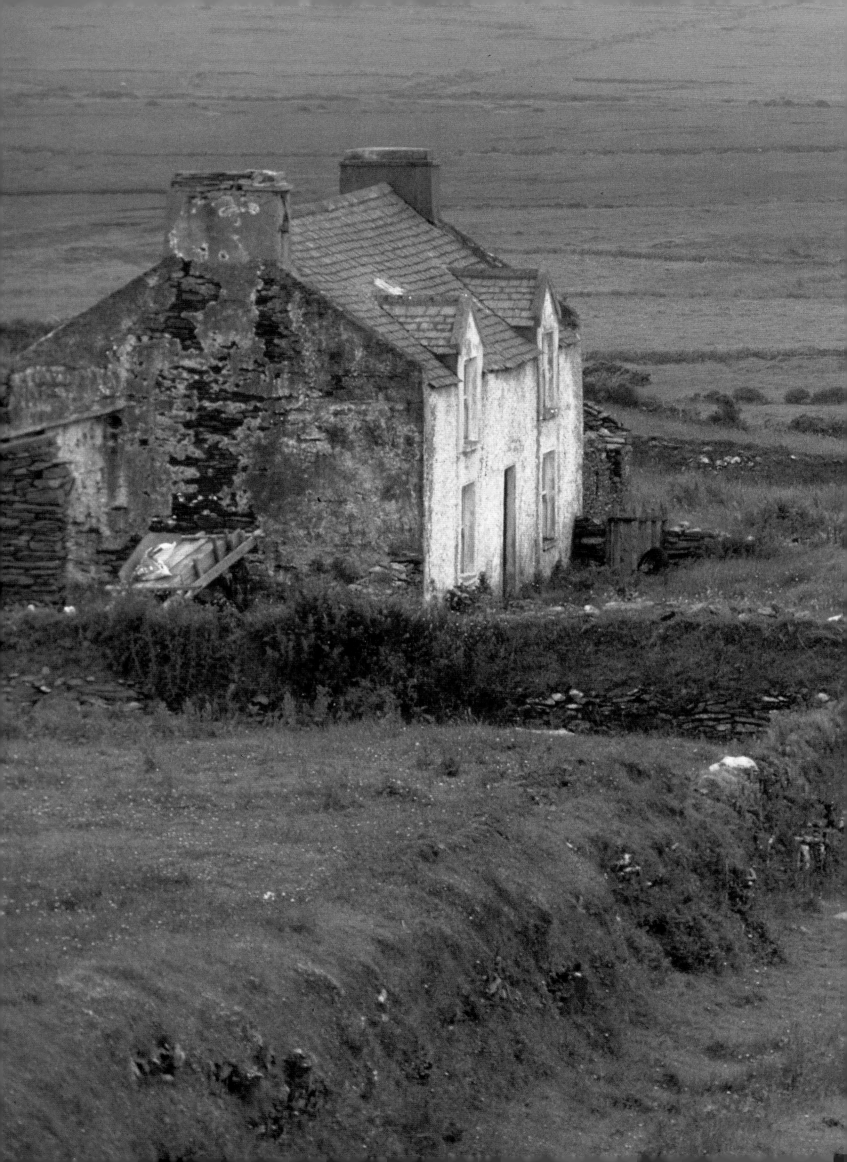

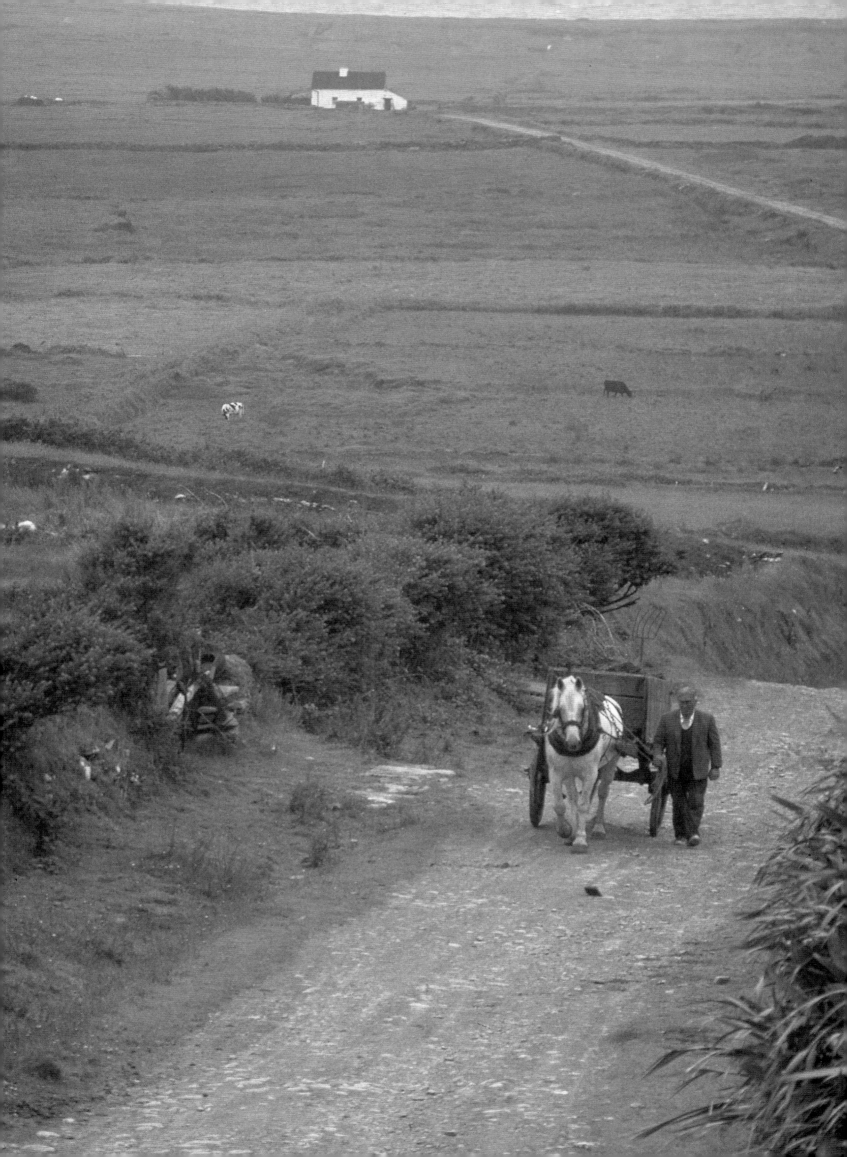

THERE IS NOT IN THE WIDE WORLD A VALLEY SO SWEET

AS THAT VALE IN WHOSE BOSOM THE BRIGHT WATERS MEET;

OH! THE LAST RAYS OF FEELING AND LIFE MUST DEPART,

ERE THE BLOOM OF THAT VALLEY SHALL FADE FROM MY HEART.

— Thomas Moore
Irish Songwriter (1779-1852)

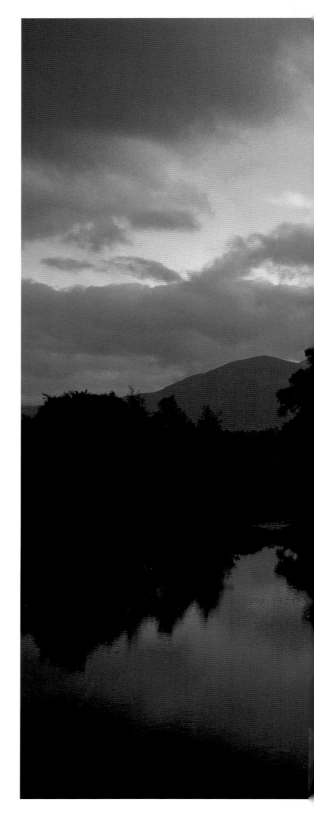

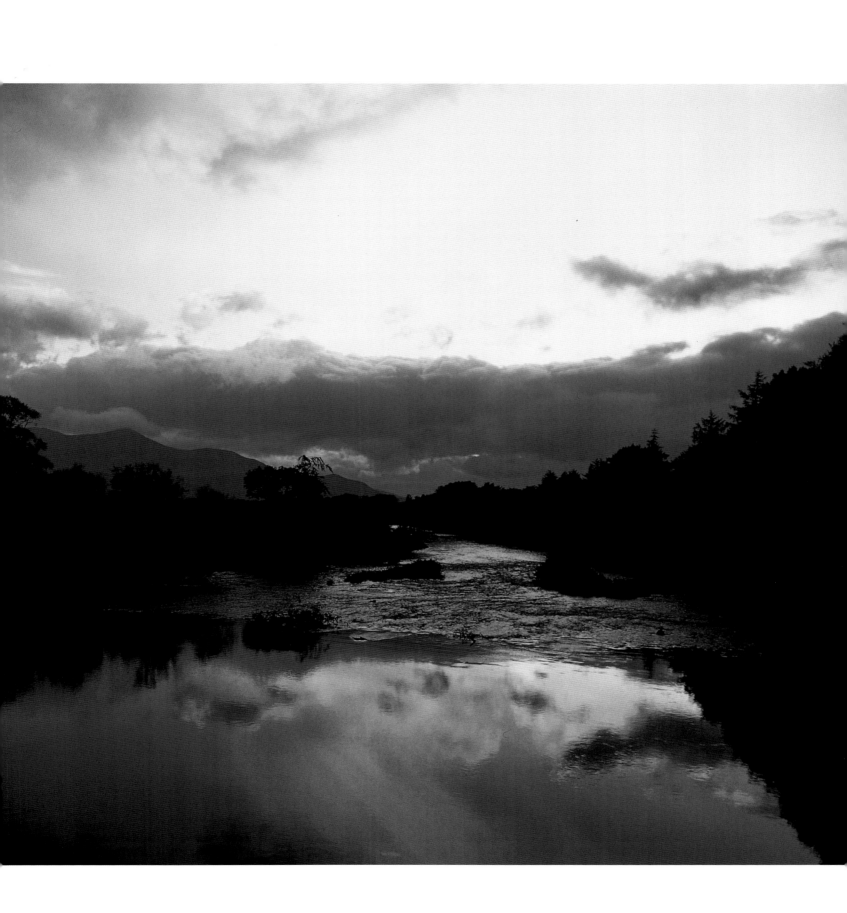

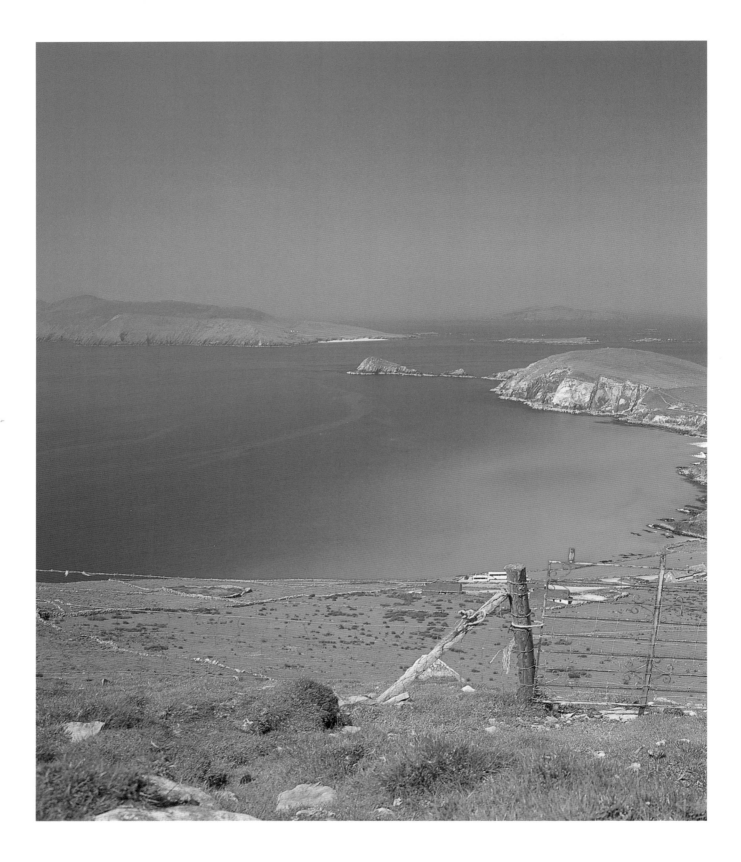

DIM DELICIOUS HEAVEN OF DREAMS—

The land of boyhood's dewey glow—

AGAIN I HEAR YOUR TORRENT STREAMS

Through purple gorge and valley flow,

WHILST FRESH THE MOUNTAIN BREEZES BLOW.

Above the air smites sharp and clear—

THE SILENT LUCID SPRING IT CHILLS

But underneath, move warm amidst

THE BASES OF THE HILLS.

— John O'Donnell
Irish Poet (1837–1874)

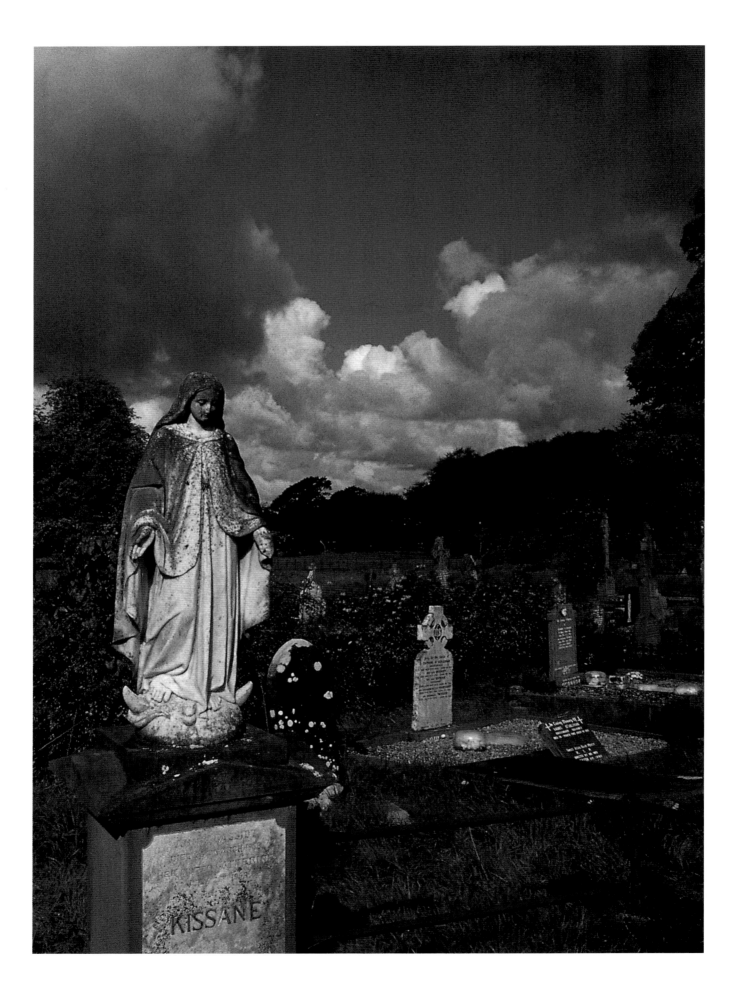

GOD MADE YOU ALL FAIR

YOU IN PURPLE AND GOLD

YOU IN SILVER AND GREEN

'TIL NO EYE THAT HAS SEEN

WITHOUT LOVE CAN BEHOLD.

— Dora Sigerson
Irish Poet (1866-1918)

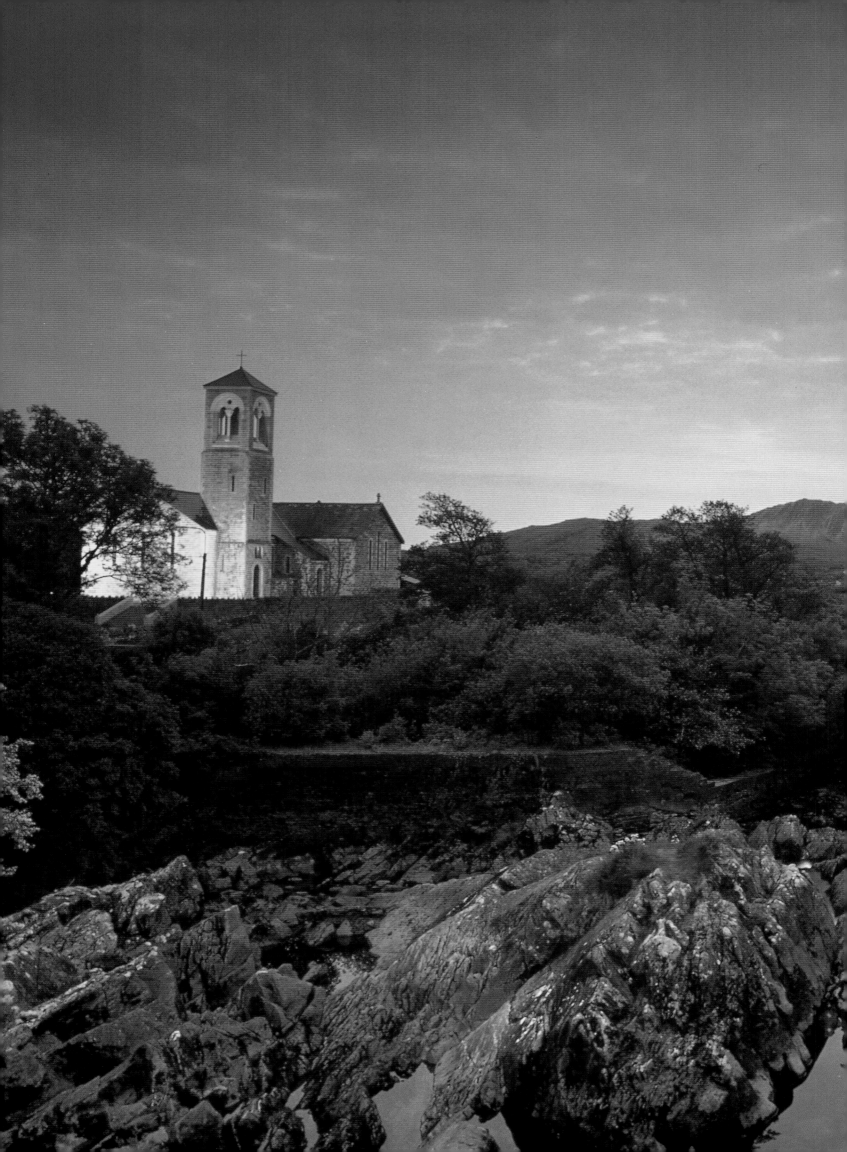

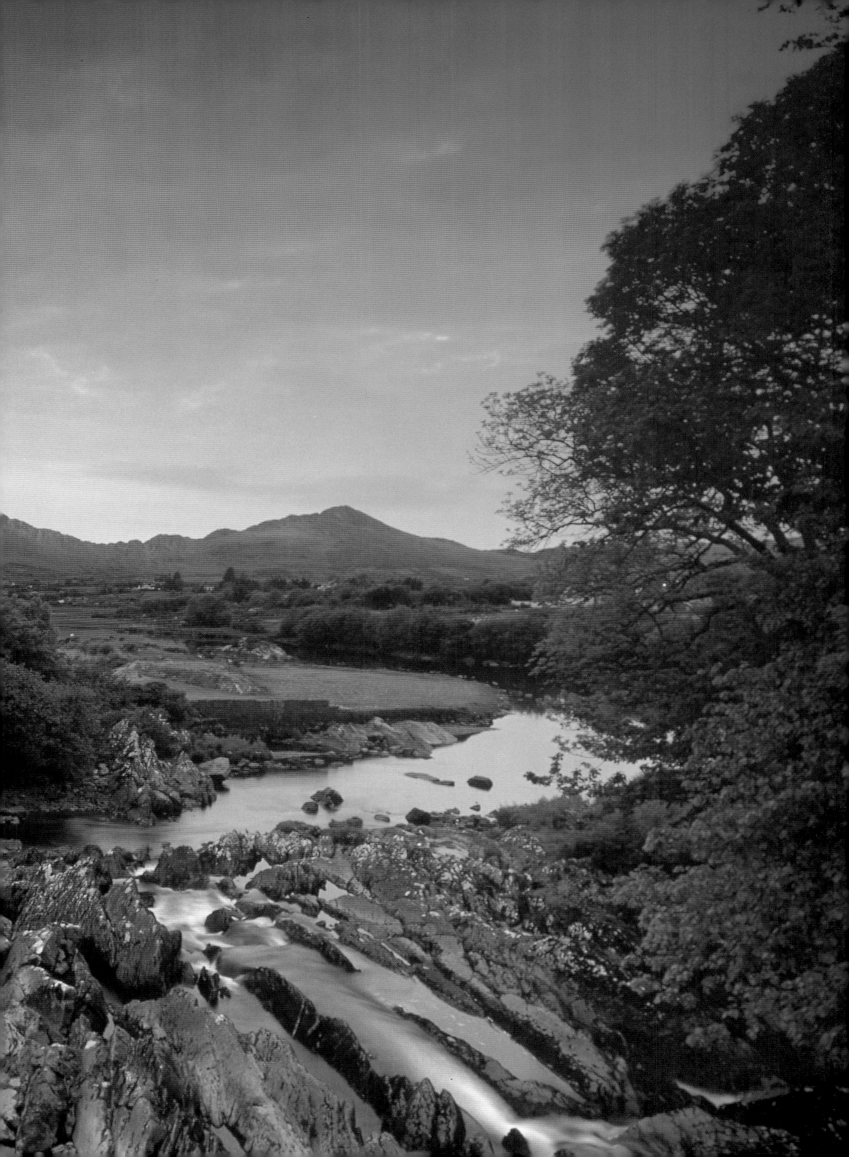

If ever I'm a money'd man, I mean, please God, to cast

My golden anchor in the place where youthful years were pass'd

Though heads that bow are black and brown must meanwhile gather grey

New faces rise by every hearth, and old ones drop away—

Yet dearer still that Irish hill than all the world beside;

It's home, sweet home, where'er I roam, through lands and waters wide.

And if the Lord allows me, I surely will return

To my native Ballyshannon, and the winding banks of Erne.

— William Allingham
Irish poet (1824–1889)

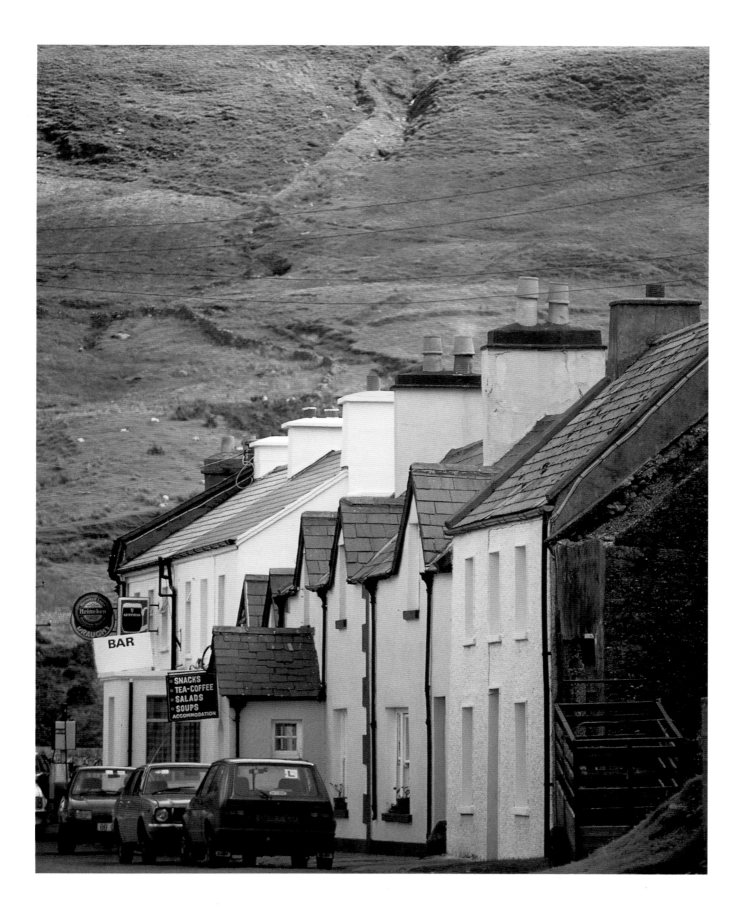

MAY YOUR TROUBLES BE LESS

AND YOUR BLESSINGS BE MORE.

AND NOTHING BUT HAPPINESS

COME THROUGH YOUR DOOR.

MAY YOUR HOME BE FILLED WITH LAUGHTER,

MAY YOUR POCKETS BE FILLED WITH GOLD,

AND MAY YOU HAVE ALL THE HAPPINESS

YOUR IRISH HEART CAN HOLD.

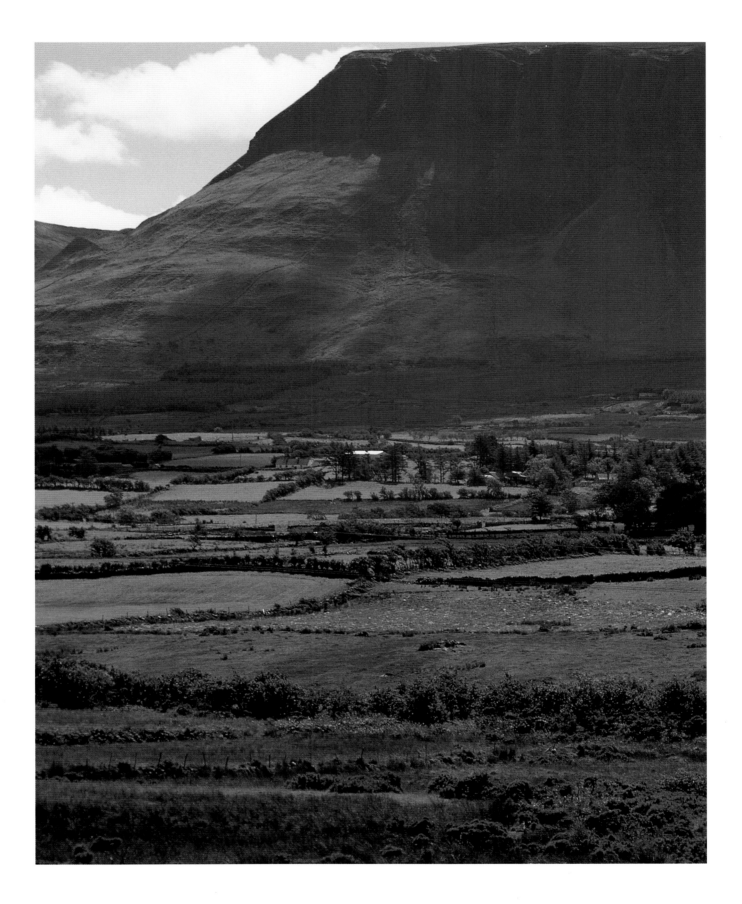

WALLS FOR THE WIND

AND A ROOF FOR THE RAIN,

AND DRINKS BY THE FIRE.

LAUGHTER TO CHEER YOU

AND THOSE YOU LOVE NEAR YOU

AND ALL THAT YOUR HEART MAY DESIRE!

MAY THE BLESSINGS OF LIGHT BE UPON YOU,

LIGHT WITHOUT AND LIGHT WITHIN.

AND IN ALL YOUR COMINGS AND GOINGS,

MAY YOU EVER HAVE A KINDLY GREETING

FROM THEM YOU MEET ALONG THE ROAD.

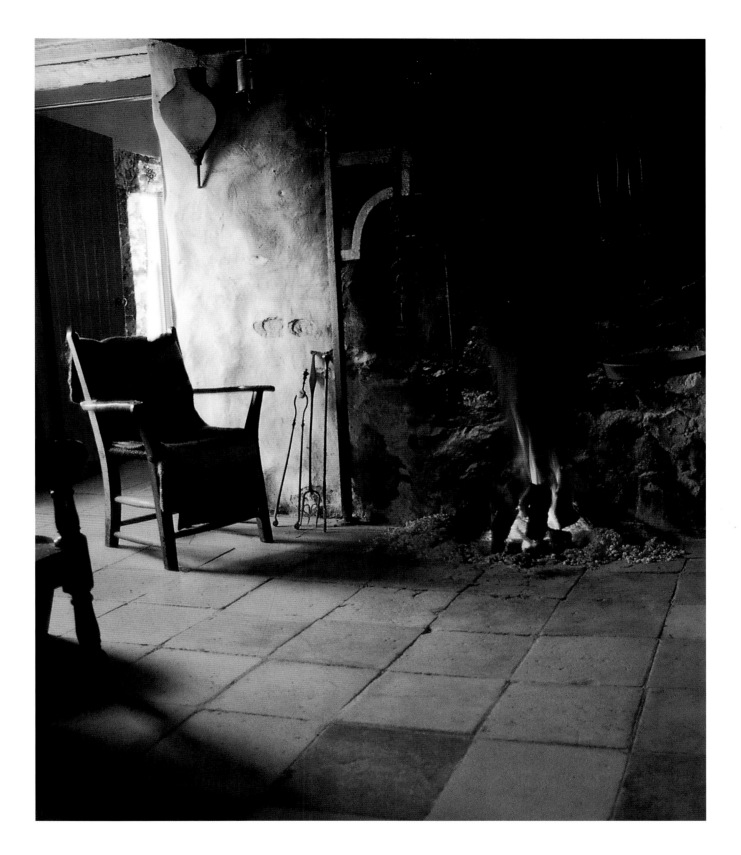

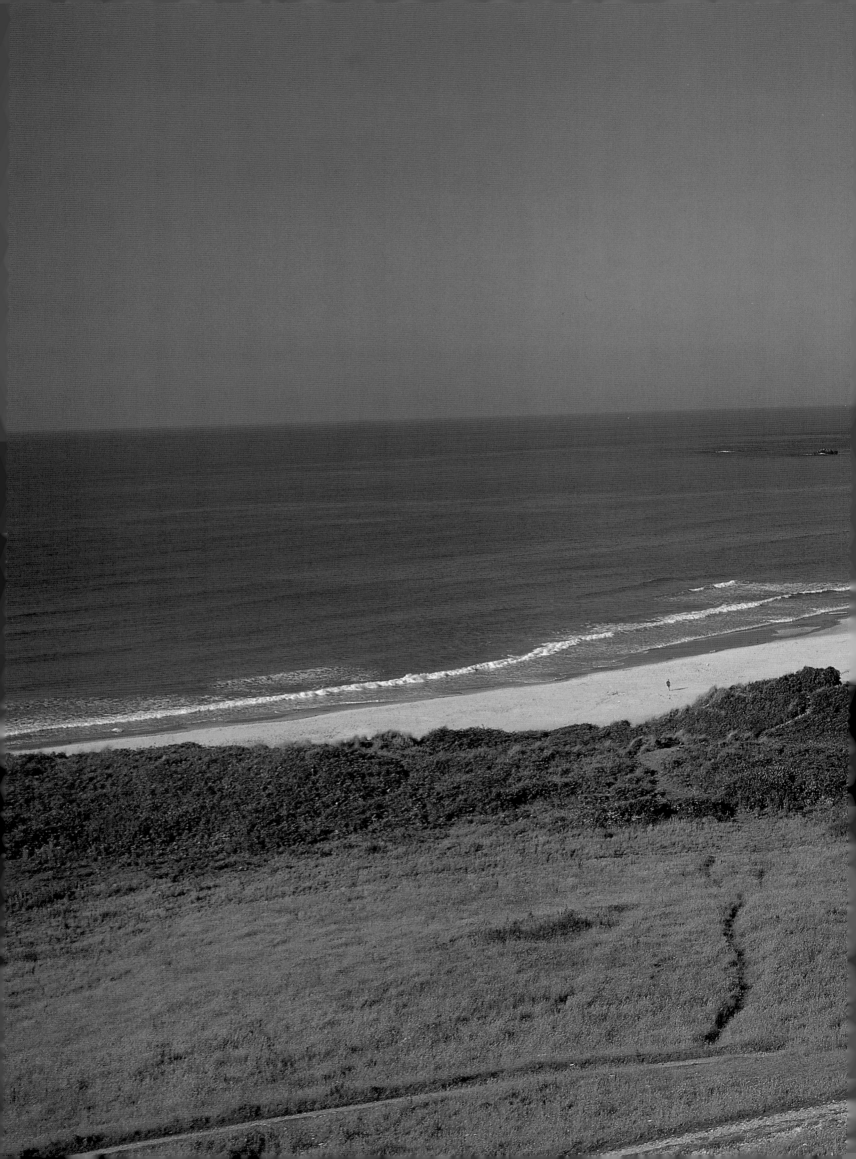

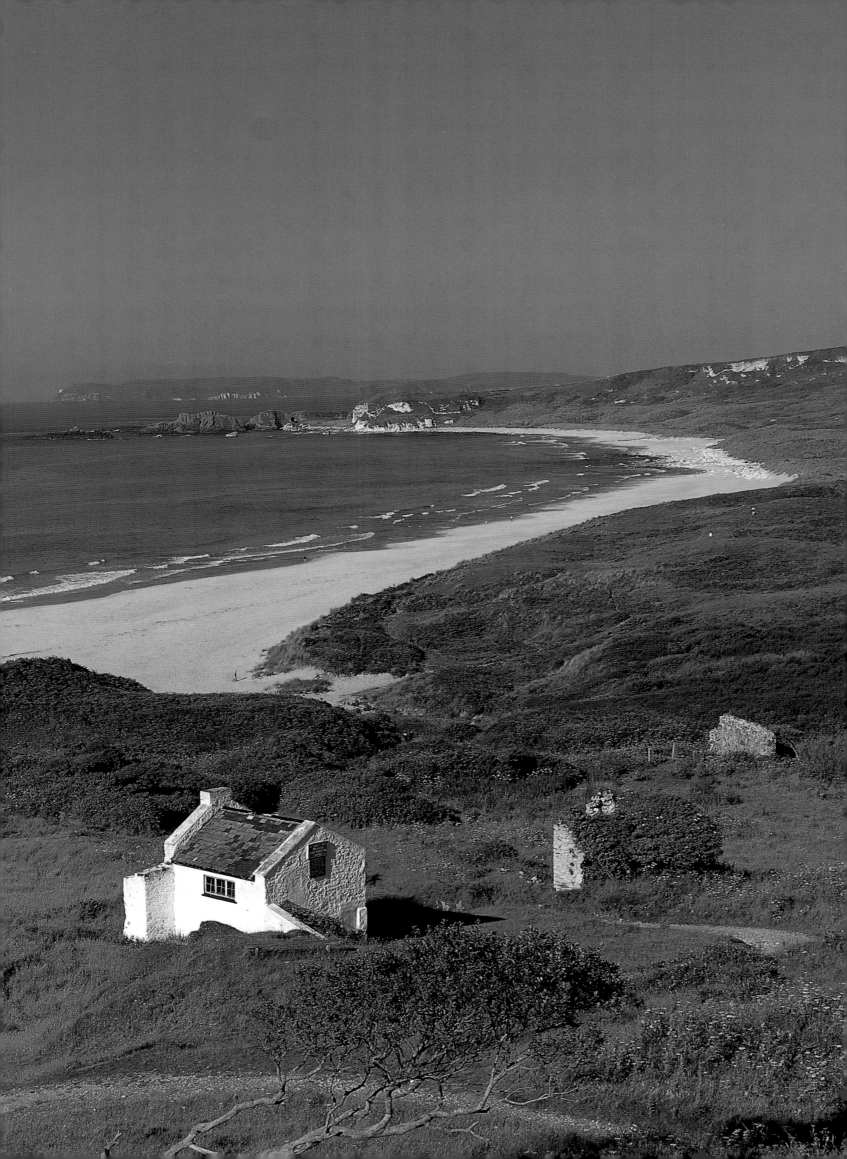

WHEREVER YOU GO AND WHATEVER YOU DO,

MAY THE LUCK OF THE IRISH BE THERE WITH YOU.

MAY YOU HAVE WARM WORDS ON A COLD EVENING,

A FULL MOON ON A DARK NIGHT,

AND THE ROAD DOWNHILL ALL THE WAY TO YOUR DOOR.

MAY GOOD LUCK BE YOUR FRIEND

IN WHATEVER YOU DO,

AND MAY TROUBLE BE ALWAYS

A STRANGER TO YOU.

May the good saints protect you

And bless you today

And may troubles ignore you

Each step of the way

May the lilt of Irish laughter

Lighten every load,

May the mist of Irish magic

Shorten every road,

May you taste the sweetest pleasures

That fortune e're bestowed,

And may all your friends remember

All the favors you are owed.

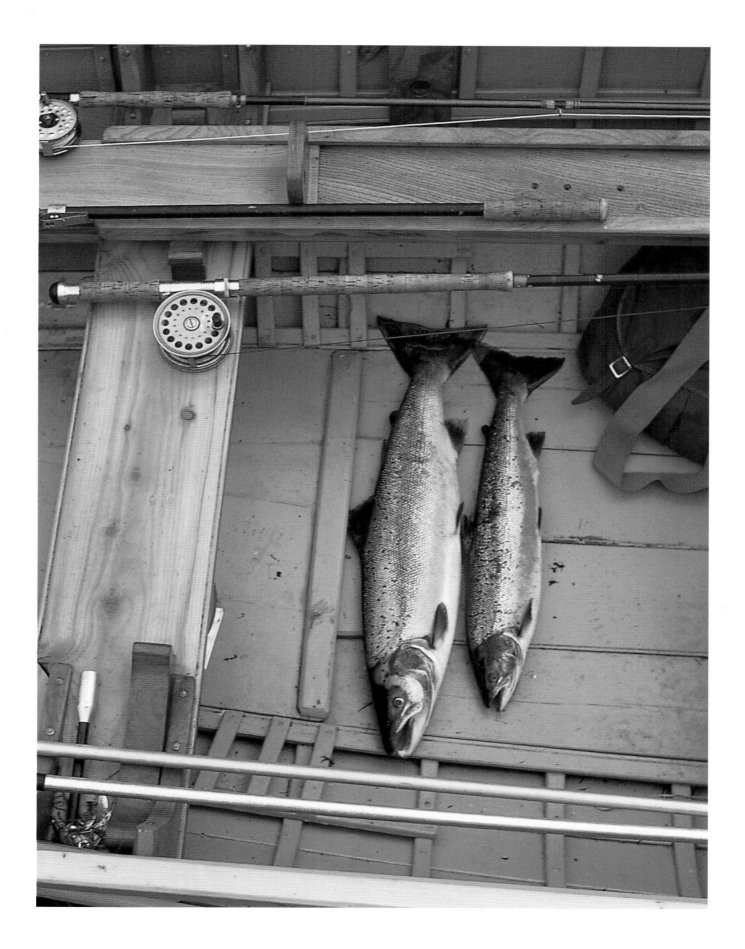

May the love and protection

Saint Patrick can give

Be yours in abundance

As long as you live.

May you have all the happiness

And luck that life can hold—

And at the end of all your rainbows

May you find a pot of gold.

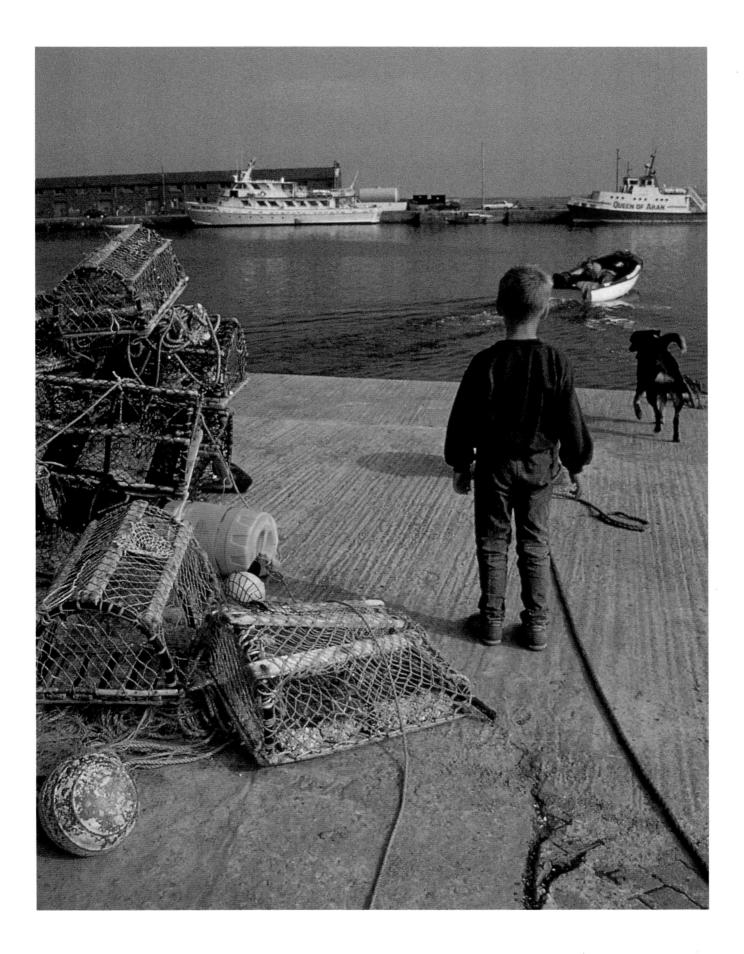

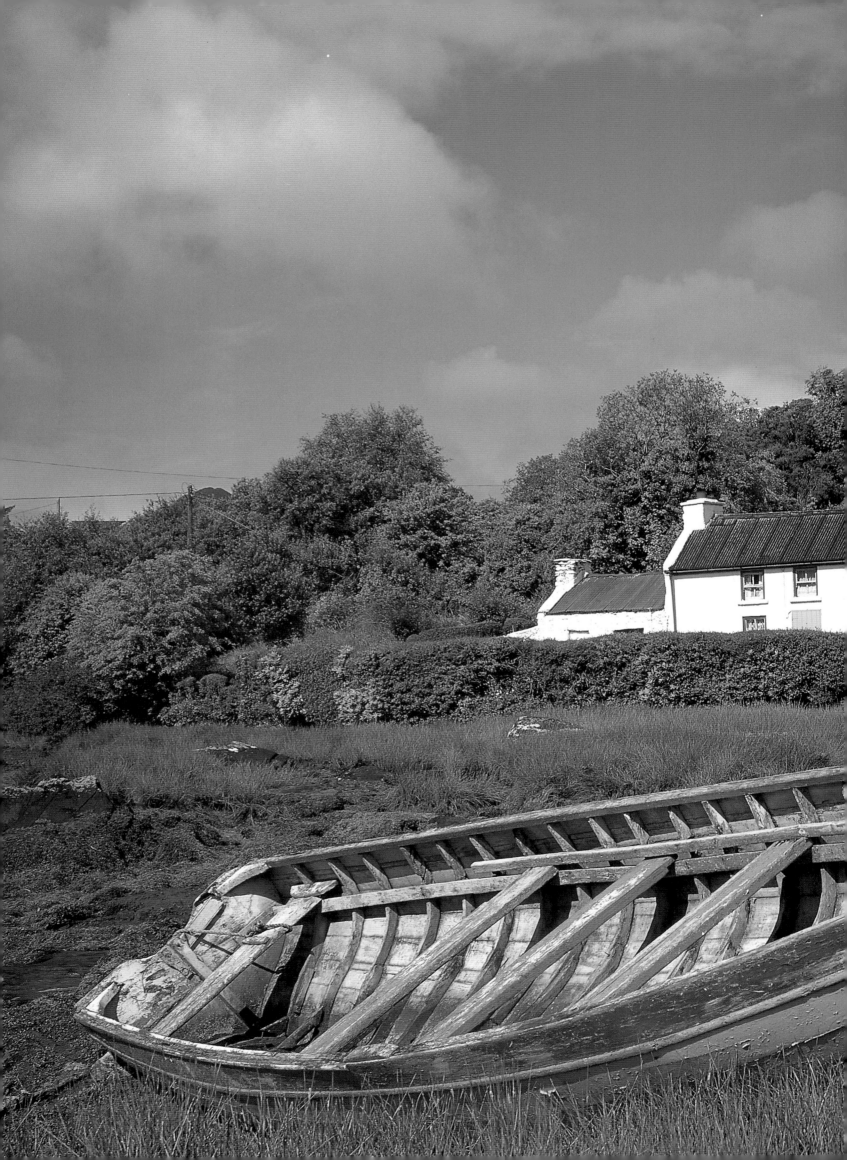

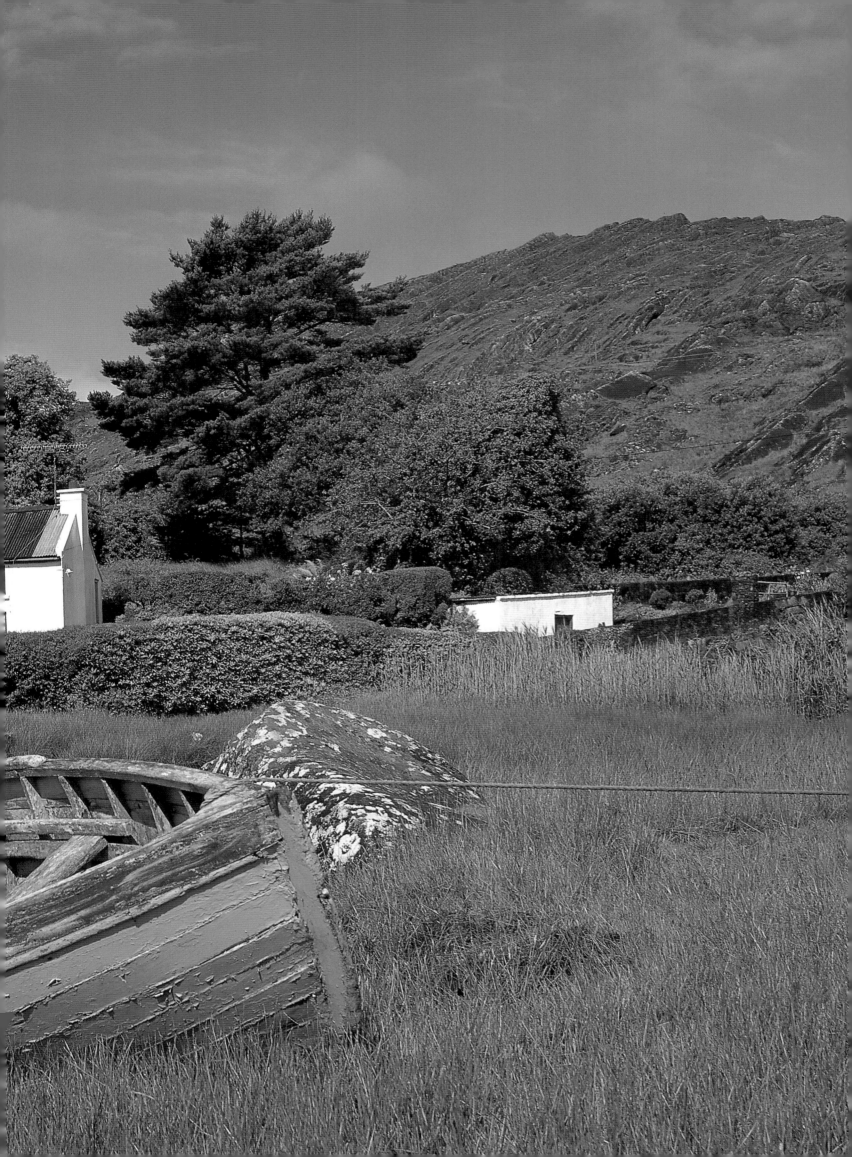

IRELAND,

it's the one place on earth
That heaven has kissed
With melody, mirth,
And meadow and mist.

May your heart be warm and happy
With the lilt of Irish laughter
Every day in every way
And forever and ever after.

May the luck of the Irish be always at hand,
And good friends always near you.
May each and every coming day
Bring some special joy to cheer you.

When Irish eyes are smiling,
Sure it's like a morning spring.
In the lilt of Irish laughter
You can hear the angels sing.
When Irish hearts are happy,
All the world seems bright and gay.
And when Irish eyes are smiling,
They'll steal your heart away.

— Traditional Irish Folk Song

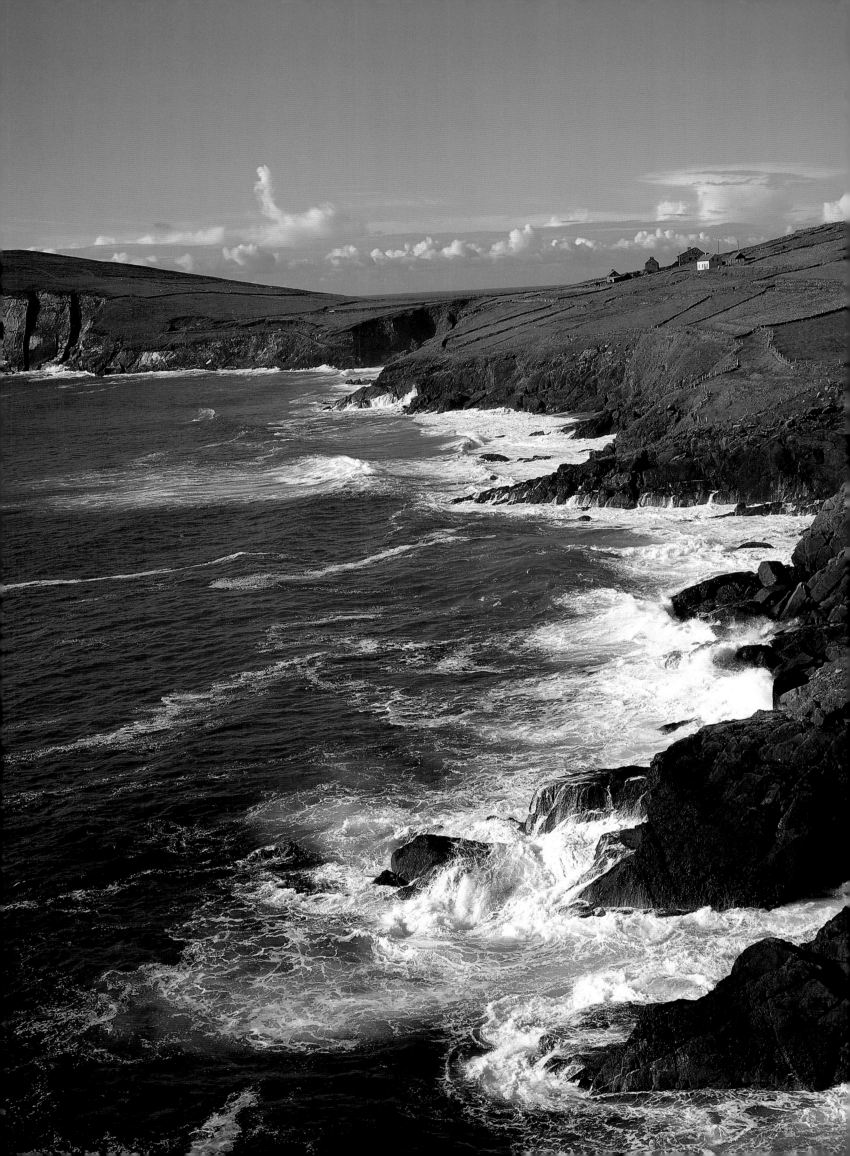

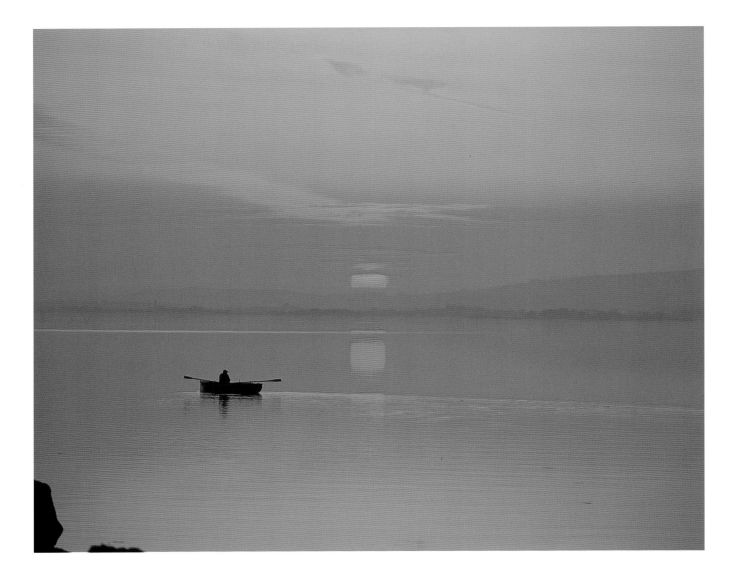

THE SAVAGE LOVES HIS NATIVE SHORE,

THOUGH RUDE THE SOIL AND CHILL THE AIR;

WELL THEN MAY ERIN'S SONS ADORE

THEIR ISLE, WHICH NATURE FORMED SO FAIR!

WHAT FLOOD REFLECTS A SHORT SO SWEET,

AS SHANNON GREAT, OR PAST'RAL BANN?

OR A FRIEND OR FOE CAN MEET,

AS GENEROUS AS AN IRISHMAN?

— James Orr
Irish Poet (1770–1816)

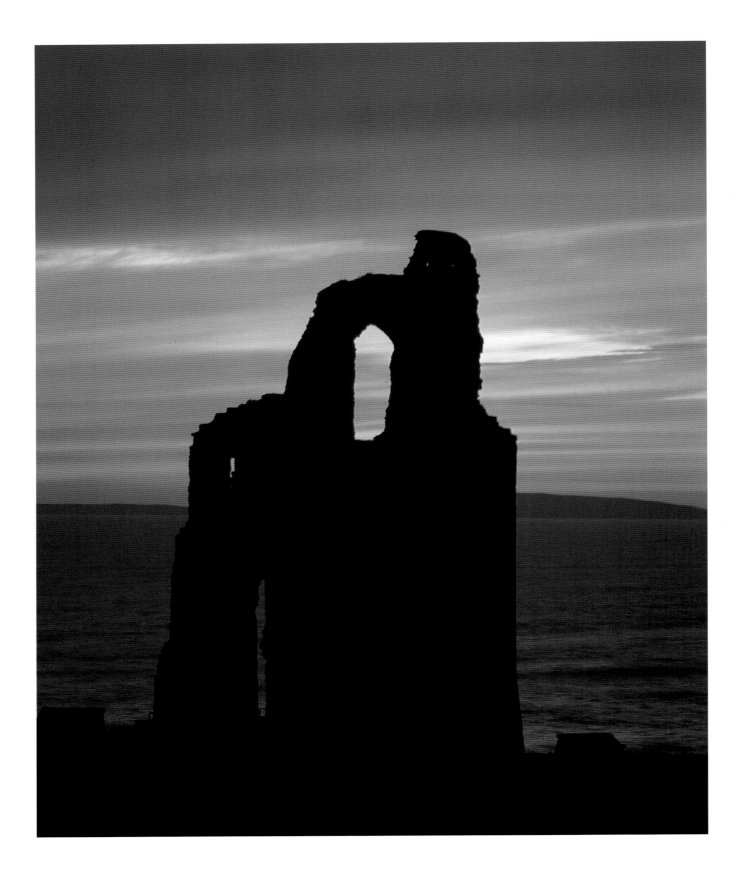

THE PILLAR TOWERS

OF IRELAND,

HOW WONDROUSLY THEY STAND

BY THE LAKES AND RUSHING RIVERS THROUGH

THE VALLEYS OF OUR LAND

IN MYSTIC FILE, THROUGH THE ISLE, THEY LIFT

THEIR HEADS SUBLIME,

THESE GRAY OLD PILLAR TEMPLES, THESE CON-

QUERORS OF TIME!

— Denis McCarthy
Irish Poet (1817–1882)

MAY YOUR THOUGHTS BE AS GLAD AS THE SHAMROCKS.

MAY YOUR HEART BE AS LIGHT AS A SONG.

MAY EACH DAY BRING YOU BRIGHT HAPPY HOURS,

THAT STAY WITH YOU ALL YEAR LONG.

FOR EACH PETAL ON THE SHAMROCK

THIS BRINGS A WISH YOUR WAY—

GOOD HEALTH, GOOD LUCK, AND HAPPINESS

FOR TODAY AND EVERY DAY.

MAY YOUR BLESSINGS OUTNUMBER

THE SHAMROCKS THAT GROW,

AND MAY TROUBLE AVOID YOU

WHEREVER YOU GO.

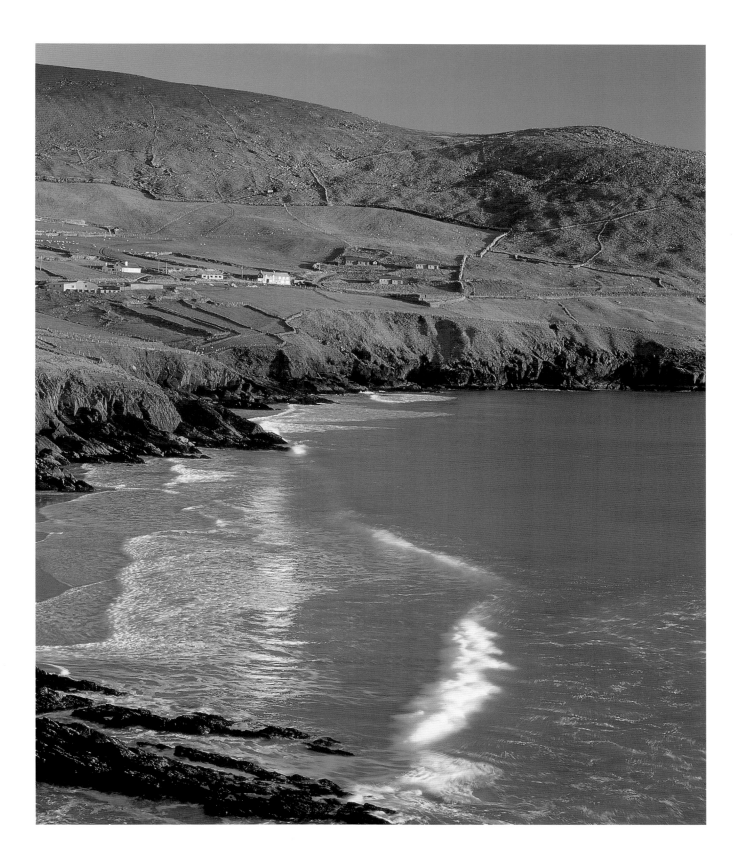

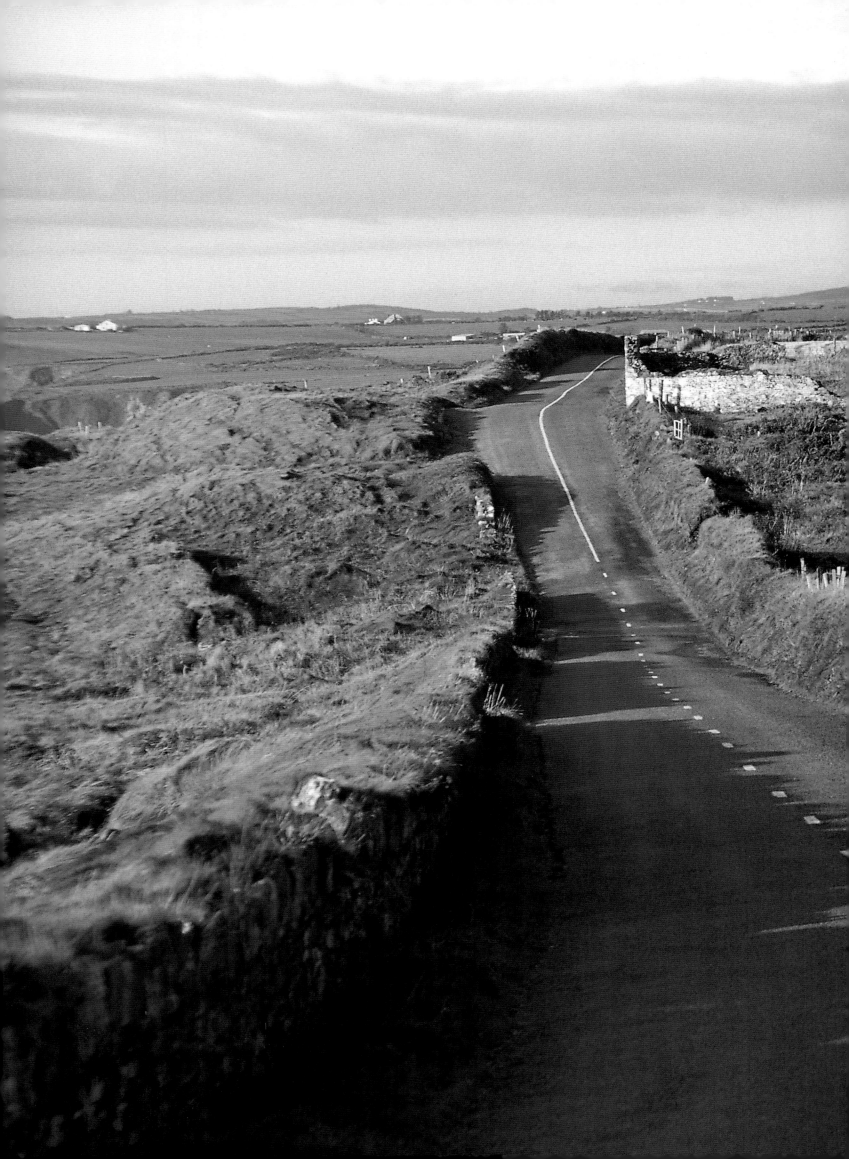

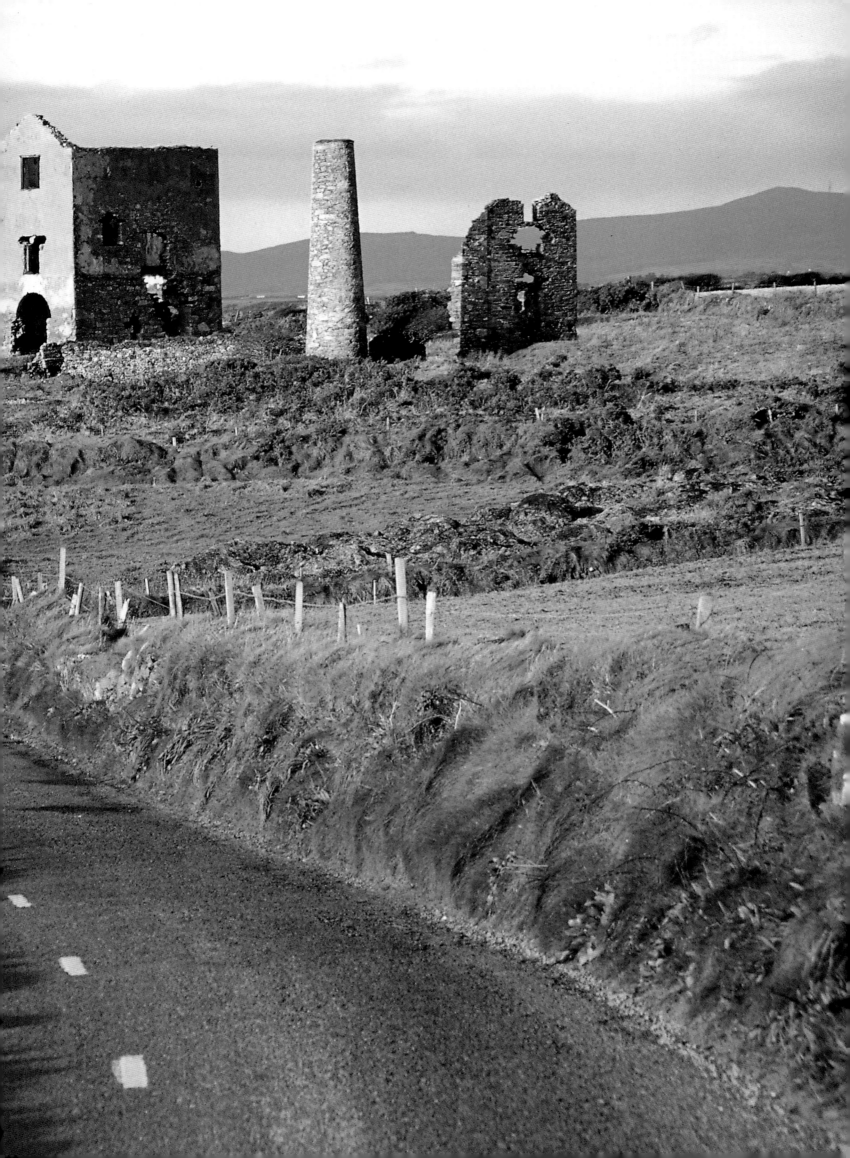

A FRUITFUL CLIME IS EIRE'S, THOUGH VALLEY, MEADOW, PLAIN,

AND IN THE FAIR LAND OF EIRE, O!

THE VERY 'BREAD OF LIFE' IS IN THE YELLOW GRAIN

ON THE FAIR HILLS OF EIRE, O!

FAR DEARER TO ME THAN THE TONES MUSIC YIELDS,

IS THE LOWING OF THE KINE AND THE CALVES IN HER FIELDS

AND THE SUNLIGHT THAT SHONE LONG AGO ON THE SHIELDS

OF THE GAELS, ON THE FAIR HILLS OF EIRE, O!

Denis McCarthy
Irish Poet (1817–1882)

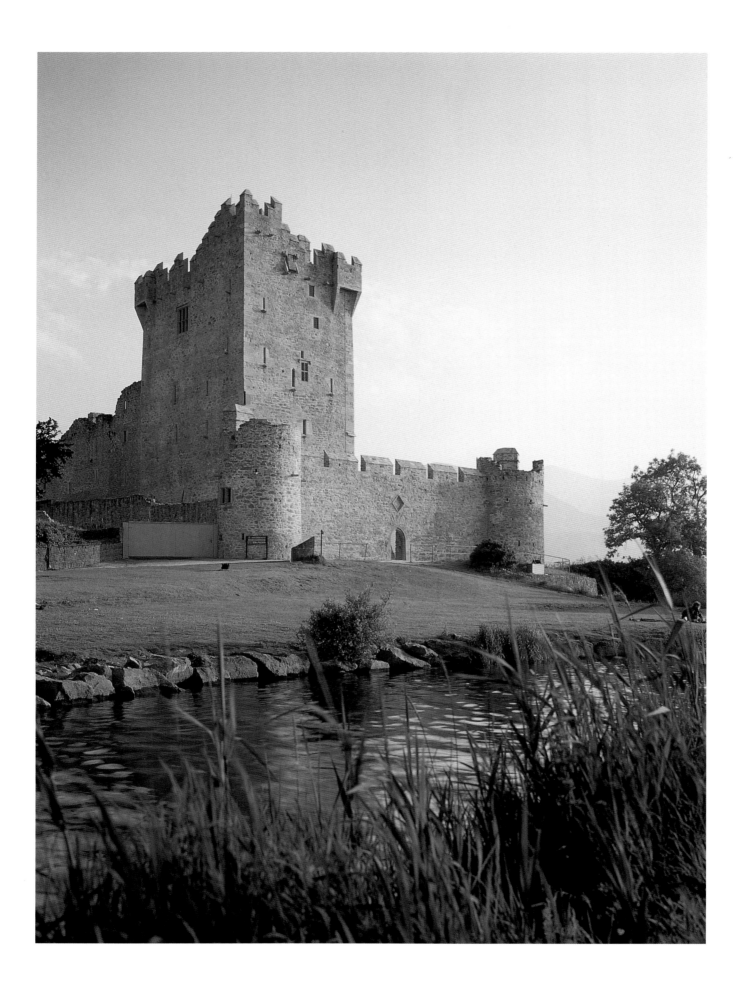

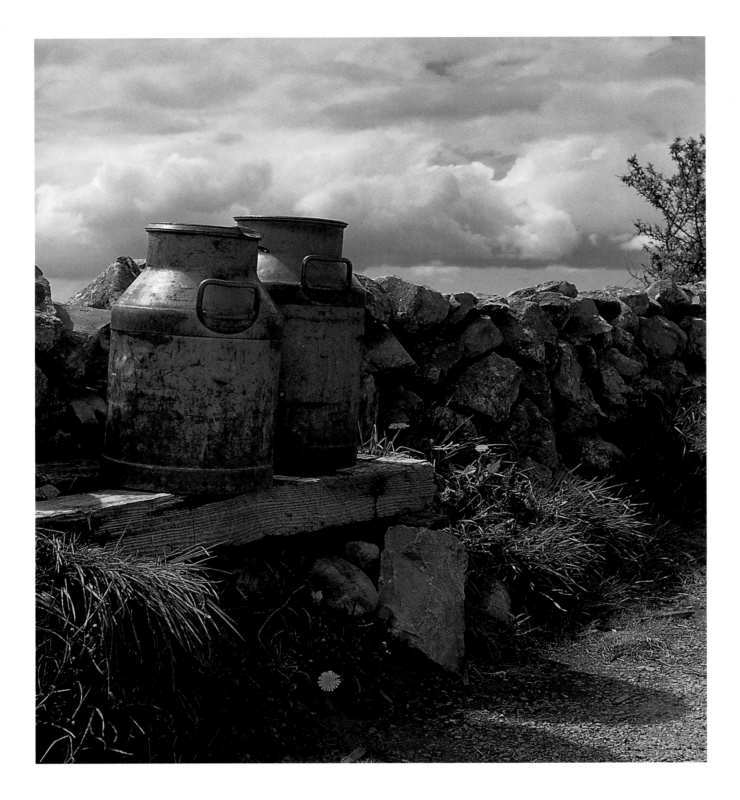

Were you ever in TIPPERARY, where the fields are so sunny and green,

And the heath-brown Slieve-bloom and THE GALTEES look down with so proud a mien?

'Tis there you would see more beauty than is on all IRISH GROUND—

God bless you, MY SWEET TIPPERARY, for where could your match be found?

— Mary Kelly
Irish poet (1825–1910)

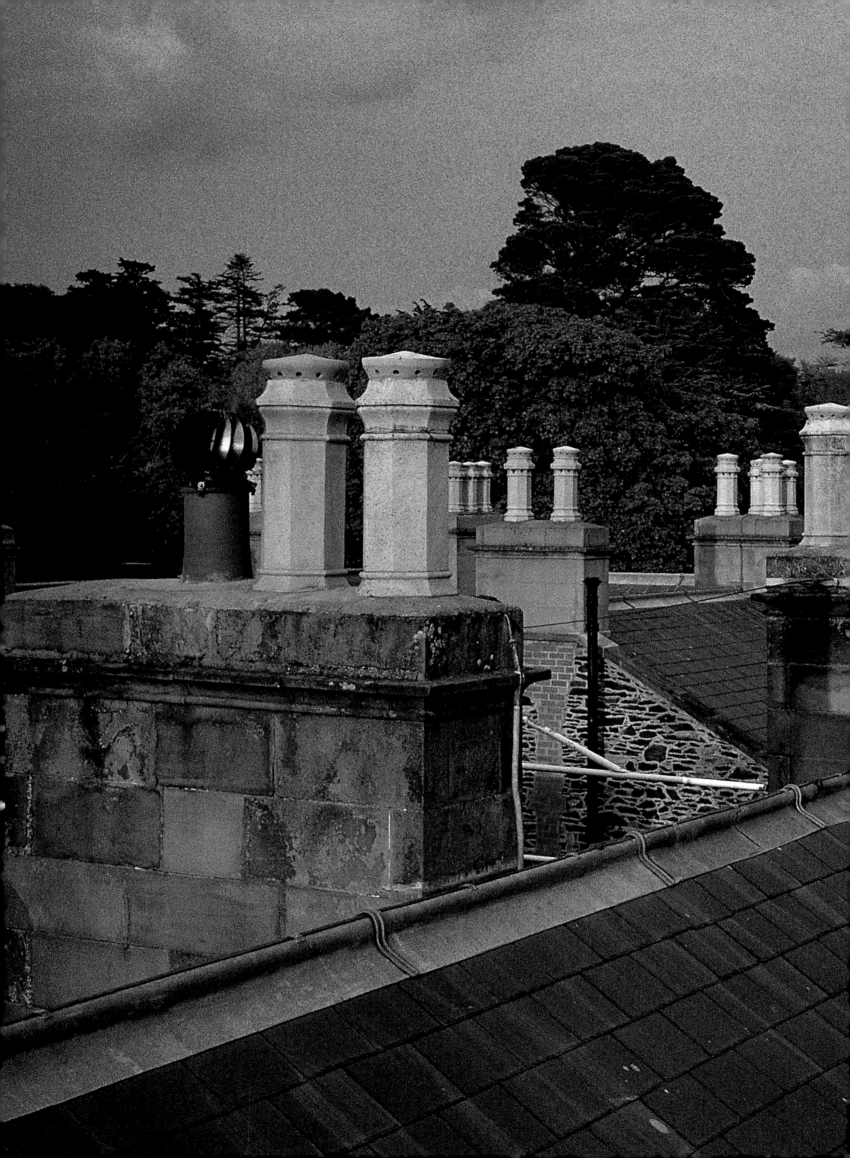

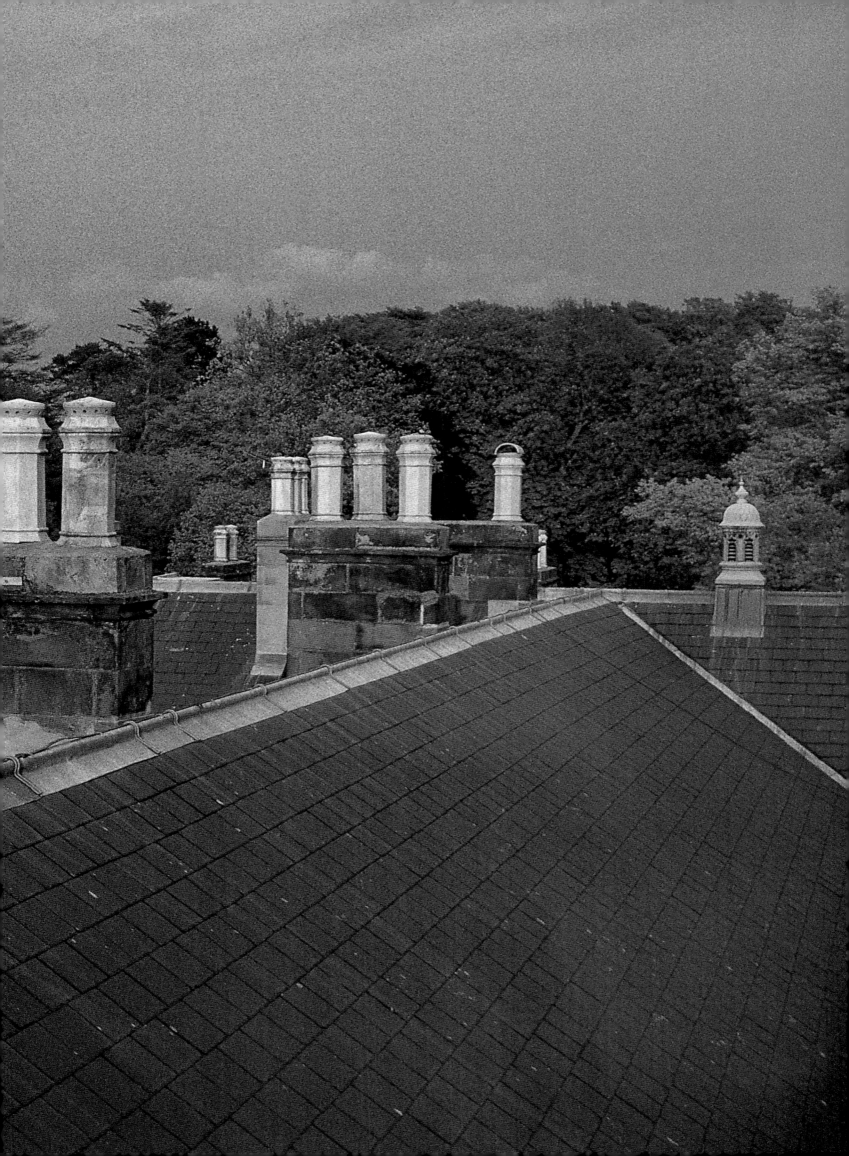

WHEN ERIN FIRST ROSE FROM THE DARK SWELLING FLOOD

GOD BLESS'D THE EMERALD ISLE, AND SAW IT WAS GOOD;

THE EM'RALD OF EUROPE, IT SPARKED AND SHONE—

IN THE RING OF THE WORLD, THE MOST PRECIOUS STONE.

— William Drennan
Irish Poet (1754–1820)

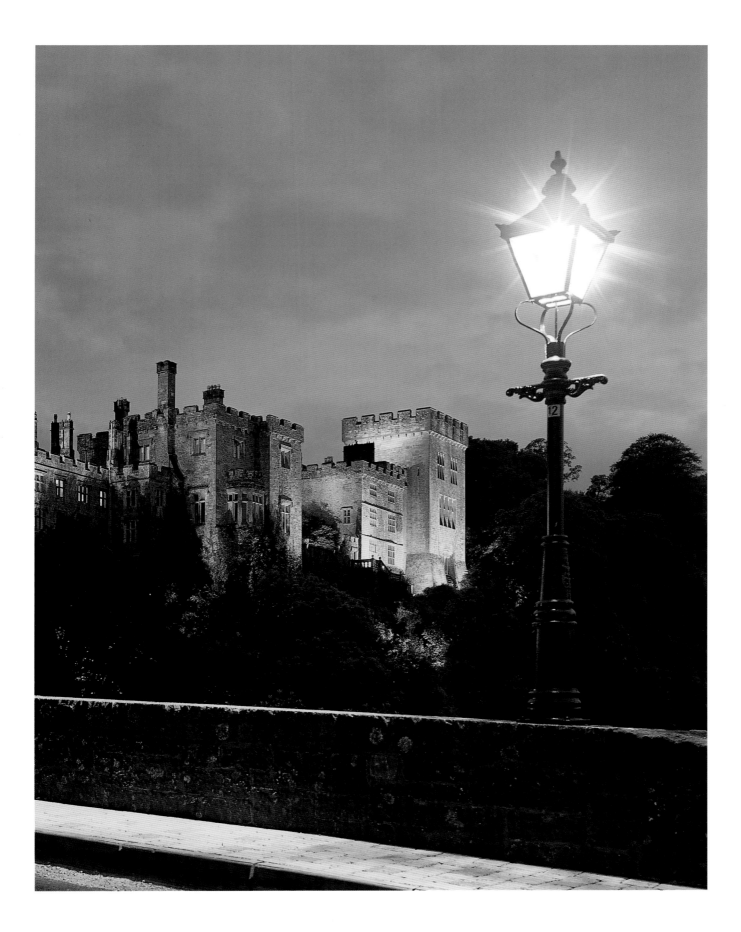

SHE IS A RICH AND RARE LAND,

OH, SHE'S A FRESH AND FAIR LAND;

SHE IS A DEAR AND RARE LAND,

THIS NATIVE LAND OF MINE.

— Thomas Davis
Irish Poet (1814–1845)

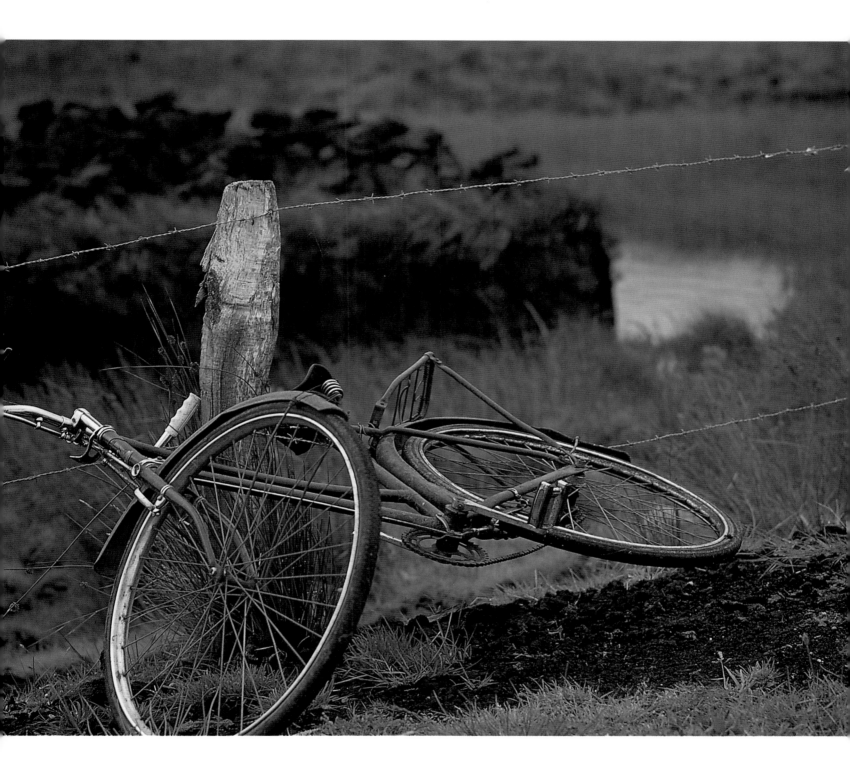

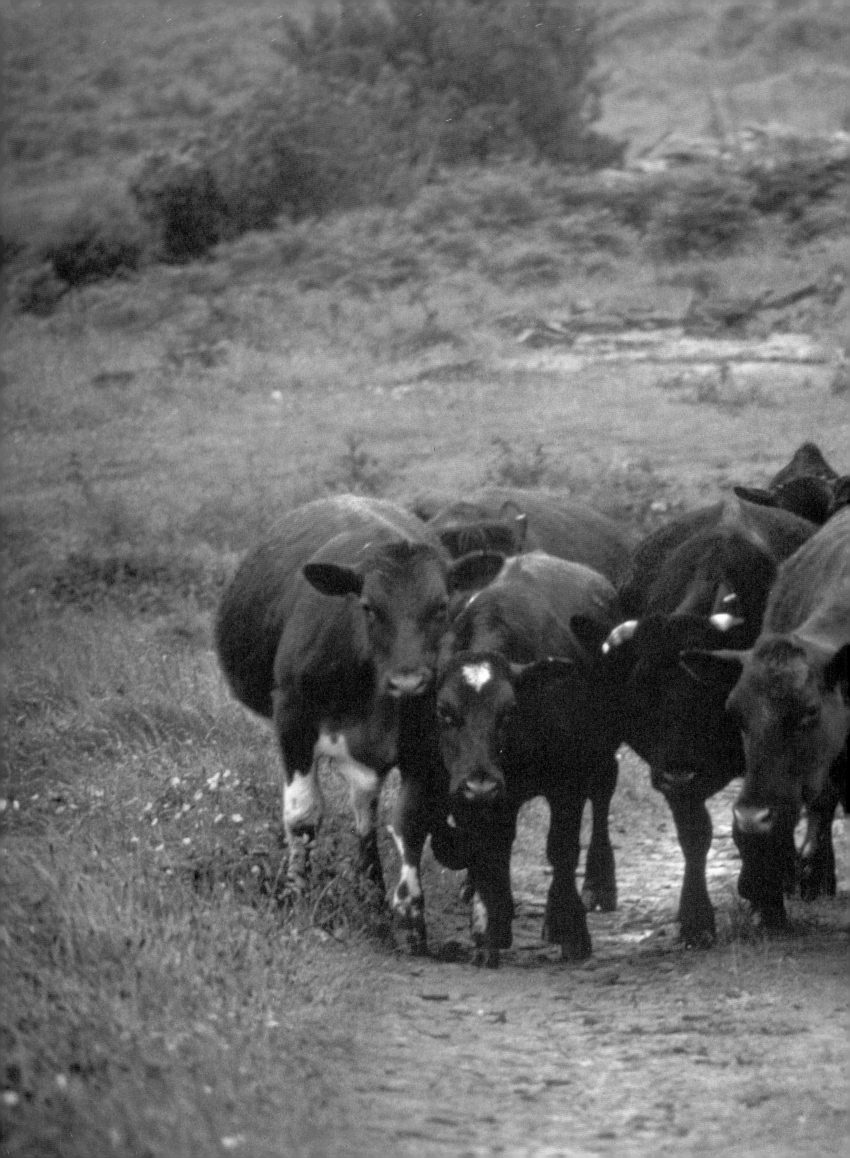

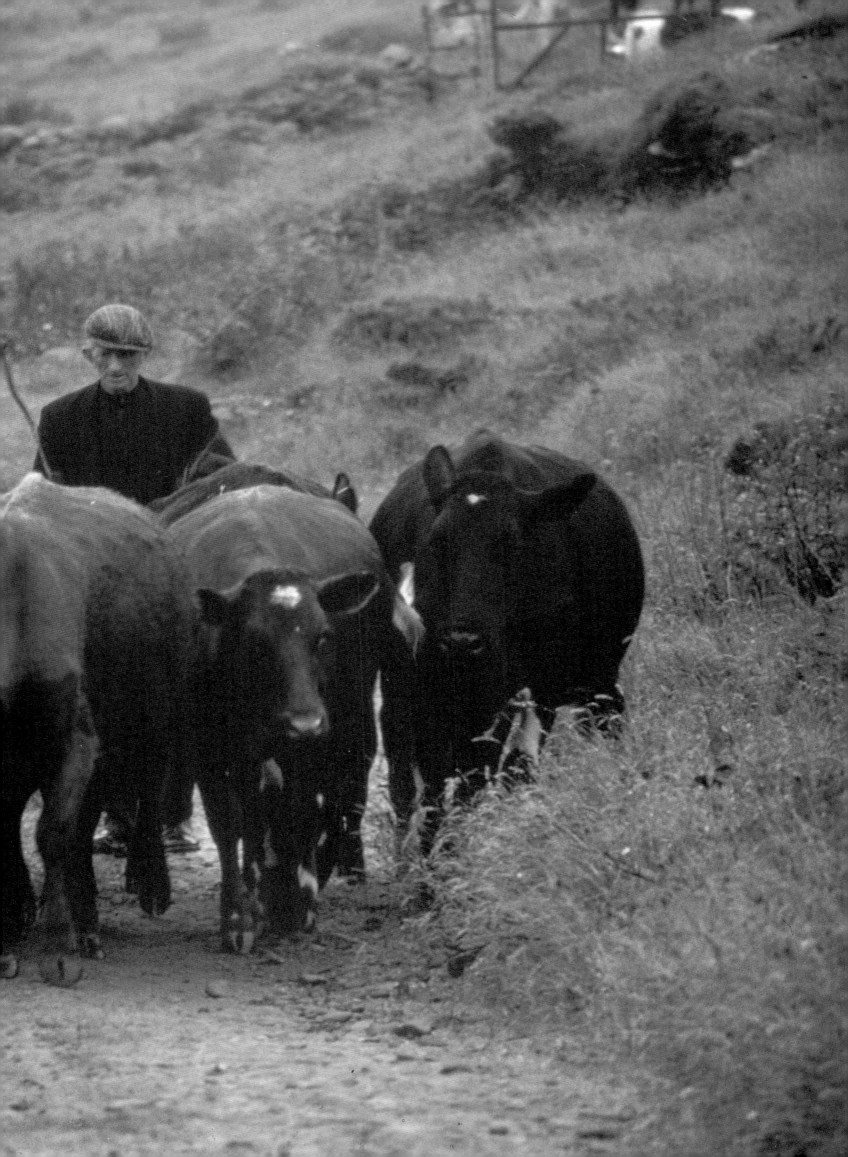

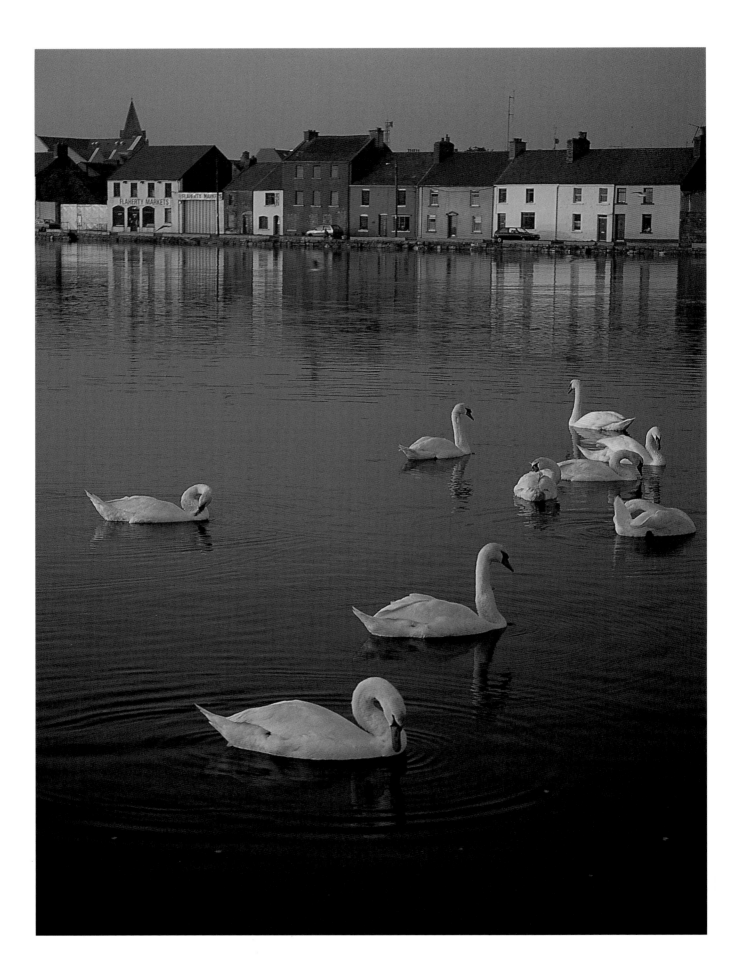

ALWAYS REMEMBER TO FORGET

THE THINGS THAT MADE YOU SAD.

BUT NEVER FORGET TO REMEMBER

THE THINGS THAT MADE YOU GLAD.

ALWAYS REMEMBER TO FORGET

THE FRIENDS THAT PROVED UNTRUE.

BUT NEVER FORGET TO REMEMBER

THOSE THAT HAVE STUCK BY YOU.

ALWAYS REMEMBER TO FORGET

THE TROUBLES THAT PASSED AWAY.

BUT NEVER FORGET TO REMEMBER

THE BLESSINGS THAT COME EACH DAY.

NOTES ON PHOTOGRAPHY:

Front cover and p. 19: Black Valley, McGillicuddy's Reeks, County Kerry
Back cover and p. 6: Boats on Kenmare River, County Kerry
p. 3: Painted window, County Kilkenny
p. 5: Dingle Peninsula, County Kerry
pp. 8-9: Galway City Harbor
pp. 10-11: Muckross Lake and Tomies Mountain, Killarney, County Kerry
p. 13: Outdoor café, Killarney
p. 14: Antrim Coast and Dunluce Castle, Northern Ireland
pp. 16-17: Cosh Harbor, County Cork
p. 20: Ballybunion, Virgin Rock at Mouth of River Shannon, County Kerry
p. 23: Glendalough Monastery, County Wicklow
pp. 24-25: Christ Statue, Glen of Aherlow, County Tipperary
p. 26: Howth Head Lighthouse, Dublin
p. 29: Killarney, Ring of Kerry, County Kerry
pp. 30-31: Man with horse and cart, Valenzia
pp. 32-33: River Flesk and McGillicuddy's Reeks, Killarney, County Kerry
p. 34 Slea Head, Blasket Islands, Dingle Peninsula, County Kerry
p. 36: Cemetery at Muckross Abbey, Killarney
pp. 38-39: River Sneem, County Kerry
p. 41: Shops, County Galway
p. 43: Benbulben Cliff, County Sligo
p. 45: Open hearth fire in cottage
pp. 46-47: County Cork
p. 48: Dublin pub
p. 51: Salmon in Loch Corrib boat, County Galway
p. 53: Kilronan Harbor, Inishmore Isle
pp. 54-55: County Antrim
p. 57: Slea Head, Dingle Peninsula, County Kerry
p. 58: River Shannon, County Tipperary
p. 60: Ballybunion Castle, River Shannon, County Kerry
p. 63: Slea Head, Coumeenole Beach, County Kerry
pp. 64-65: Ruins on coastal road, Annestown, St. George Channel, County Waterford
p. 67: Ross Castle, Killarney, County Kerry
p. 68: Roadside milk churns, County Clare
pp. 70-71: Chimney tops, Mt. Stewart
p. 73: County Waterford
pp. 74-75: Bicycle at a bog, County Kerry
pp. 76-77: Man herding cows, Dingle Peninsula
p. 78: Galway swans